DIGITAL CAPTURE
AND WORKFLOW FOR PROFESSIONAL PHOTOGRAPHERS

TOM LEE

AMHERST MEDIA, INC. ■ BUFFALO, NY

Copyright © 2007 by Tom Lee.
All photographs by the author unless otherwise noted.
All rights reserved.

Published by:
Amherst Media, Inc.
P.O. Box 586
Buffalo, N.Y. 14226
Fax: 716-874-4508
www.AmherstMedia.com

Publisher: Craig Alesse
Senior Editor/Production Manager: Michelle Perkins
Assistant Editor: Barbara A. Lynch-Johnt

ISBN-13: 978-1-58428-200-6
Library of Congress Control Number: 2006930069

Printed in Korea.
10 9 8 7 6 5 4 3 2 1

Notice of Disclaimer: The information contained in this book is based on the author's experience and opinions. The author and publisher will not be held liable for the use or misuse of the information in this book.

CONTENTS

Facing page—Bridesmaid portrait made with ambient light and a fill flash. Postproduction work on the image included vignetting, the application of Nik Color Efex Pro's Midnight filter, and a slight boost in saturation.

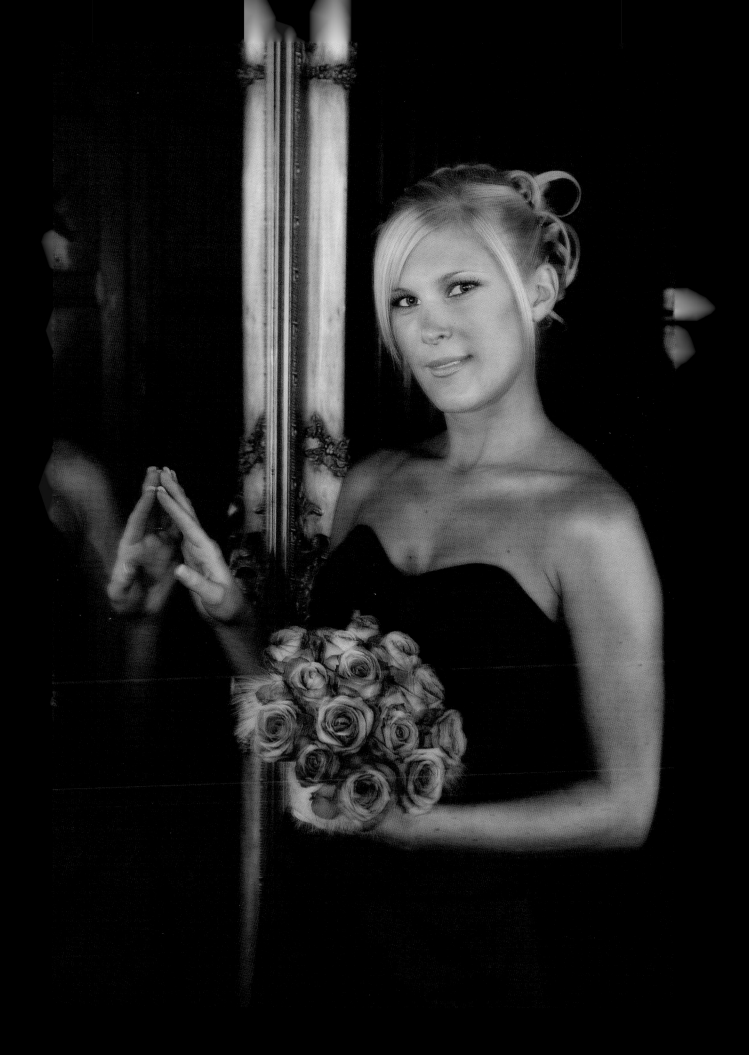

AUTHOR PROFILE

Leaving education as a frustrated artist, Tom turned to architecture, and life with a drawing board, then later trained as a structural engineer. At the tender age of 21, he was introduced to photography. His first camera was a rudimentary affair including two zoom lenses. When looking back, it's difficult to see how, when picking up that camera, his hobby, vocation, and entire life would revolve around taking pictures. Like most budding enthusiasts, he joined a succession of camera societies, learning basic and advanced skills and became successful at the national competition level.

Realizing the need to develop and improve his skills in the photographic market, Tom attended many lectures and seminars organized by the SWPP and gained Licentiate and Associate qualifications. Now recognized for his expertise in digital image capture, Tom is also noted for his storybook style of wedding albums, involving montage-style pages and softly blended backgrounds. Tom uses stylish Italian albums and the latest technology, and clients are expected to pay a high premium for his work.

Tom has since given many seminars in the UK and written extensively for the SWPP magazine *Professional ImageMaker*. He was awarded a Fellowship of the SWPP in 2002 in recognition of his services to the industry and made vice president of the SWPP and BPPA in the same year. Tom is also a member of NAPP (National Association for Photoshop Professionals) and WPPI (Wedding and Portrait Photographers International). His recent success in their open print competition is testament to his skills in competing with the best in the world.

As of this writing, Tom is the holder of the Overall Contemporary Album of the Year Award. It's also the second time in three years that Tom has won this national competition organized by the SWPP.

Photography is not just about technical competence; this is only one aspect of the art of weddings and portraiture. Many photographers who call themselves artists fail to convey to their audiences the emotional impact of the subject. In Tom's case, however, his well-learned and practiced skills on the technical side have left him free to develop the aesthetic side and use his judgment to project his own feelings for his subjects into the picture and the viewers' consciousness.

The vitality and insight captured via the use of light and shadow in his portraits provide a unique view that can stand side by side with the best. His work holds beauty, grace, authority, and influence of real people for us all to experience.

Photography, unlike any other profession, brings us into close and personal contact with an astonishing range of people including painters, sculptors, actors, musicians, and socialites. Many become lifelong friends and also the subjects of our portraits. Tom is a master of poetic photography, a true photographic artist. With a career spanning 25 years, he has made a distinctive contribution to photographic portraiture.

—*Jonathan Brooks, M.Photog. (USA), FSWPP*

ACKNOWLEDGMENTS

There are so many people to thank that it would take at least another book to list all their names. Let's start with Karl, without whom I would never have picked up my first camera. My thanks, also, to mentor Terry Hansen and close friends Jonathan Brooks, Andrea Barrett, Aled Oldfield, Mike McNamee, and Phil Jones, who are my greatest support and great British photographers in their own right.

American friends Rick and Deborah Ferro, Bambi Cantrell, Dave Newman, and Norman Phillips have broadened my outlook on world photography and entertained me during my trips to WPPI.

My thanks also to everyone at Amherst Media—especially Craig Alesse, who has shown faith in me and allowed me to publish my first BIG book.

Many people often ask me, "How do you get to know so much?" The simple answer is that I practice, not just with Photoshop but with all the tools of the photographic trade. I keep up to date by reading the latest photo publications, and I talk with and see lecturers from all over the world, not just on my doorstep. Jane Connor-Ziser, Charles Green, Dennis Reggie, Hanson Fong, Maz Mashru, Jerry Ghionis, Yervant, and Monte Zucker have all had an effect on my style and technique to some degree or other. It's cost me a lot of money to see some people, but without the teachings of these photographic masters, I would not have had the courage to make this book possible. I thank them all.

Of course, we can't take pictures without equipment, and I also thank Fuji and Nikon for their support. My great friends Sandy and Debbie of Anna May Couture have assisted with models and bridal wear. Mike McNamee has kept me straight and narrow with advise on technical matters. Without him, the world of color calibration would fall apart!

And last but certainly not least, I thank my wife, Karen, who has kept me fed and watered during the long hours of script writing and has the patience of Job to put up with me for over 25 years.

There are so many people to thank that it would take at least another book to list all their names.

INTRODUCTION

A beautifully crafted album starts with some carefully chosen capture settings.

Digital imaging is a monster, but it can be tamed. Many photographers get hung up on the technology involved in shooting and processing their images and forget the posing, composition, and lighting basics. They

When you learn to fine-tune your capture and maximize your workflow efficiency, you can spend more time capturing heirloom images for your clients.

become button pushers who think any mistake can be corrected in Photoshop. The reality is, if we don't capture the image correctly in the first place, no amount of tweaking in Photoshop will help.

Freedom from film and processing costs has encouraged photographers to shoot more images, and that means that photographers are spending an ever increasing amount of time behind their computers processing the results.

Photoshop opens up a world of opportunity for the creative artist. However, even artists need some time off, and I prefer not to starve. This is where

the importance of workflow comes in. Basic tasks need to be completed quickly and efficiently in order to move on to other things. This can be achieved without sacrificing your artistry, but you need to balance the effort "out" against profit "in."

We have assumed that the reader has some basic knowledge of Photoshop (e.g., how to access all of the tools and where the various palettes are located). We'll cover capture modes and camera settings. We'll learn how to set up actions in Photoshop CS2 and to implement an effective, efficient workflow for image processing and album design. We'll also cover image presentation, competition printing, and more.

Let's dive in and get started.

This simple yet effective studio portrait was made with three lights.

IMAGE CONTROL

Photographers have a myriad of choices when it comes to selecting their favorite weapon. It would be difficult to recommend any particular manufacturer or model, however, as new models are introduced before buyers can even pull their purchase out of the box. We will therefore discuss things only in general terms.

With so many digital controls at your fingertips, it's tempting to throw in the towel and just set your camera to its program setting. However, people who have gone this route have found that this is not the answer. The variety of scenarios you will need to shoot in, from the constant light in your studio to the variable light quality you'll come across in an outdoor shoot, require a varied approach.

Each model allows various capture modes and a means of controlling sharpness, color, tone, and contrast.

Though the camera may feature a host of gadgets and buttons that can do everything but make tea, each allows various capture modes (JPEG, TIFF, and RAW) and a means of controlling sharpness, color, tone, and contrast. If we can find a balance between optimum camera setup (not auto) and minimum camera adjustments, we will create high-quality images with minimal fuss.

In this chapter, we'll look at the seven controls needed to make the most of your image: white balance, pixel count, color, tone, sharpness, exposure value compensation, and capture mode.

White Balance

Our eyes are very good at adjusting to the color temperature of light in a given scene, but our cameras have great difficulty performing that task. As a result, the images we capture are sometimes affected by a green or blue color cast that ruins an otherwise acceptable image.

Facing page—This location portrait was photographed in color at Red Rock Canyon, Nevada. The image was then converted to black & white using the Mono action described in chapter 12.

To prevent this problem, film photographers selected an emulsion to match their light source and/or placed colored filters over their lenses. Digital cameras offer an auto white balance setting, several presets (e.g., tung-

sten, daylight, etc.), and the ability to set a custom white balance. The camera then applies a mathematical algorithm to capture the "true" color of your subject. While this can help to reduce the time spent correcting the image in Photoshop, it's not foolproof, as anyone who has tried the auto white balance setting knows.

Resolution, Compression, and Capture Mode

The image resolution, compression format, and compression level that you select will determine the quality of the final image. In general, higher resolution and lower compression means larger files, which are a requirement for larger, higher-quality prints.

When you are shooting, your camera saves your image data using a compression format to reduce the amount of data stored on the memory card. Personal preference (and sometimes ignorance) plays a large part in which format photographers use. The following discussion will help you understand how to choose the option that best suits your needs.

JPEG. JPEG is a lossy compression format. This means that to make the file size smaller, the camera throws away image data—and it cannot be reclaimed. The camera's algorithms utilize a linear conversion of the recorded information to produce the final image, and the control settings for white balance, contrast, saturation, and matrix conversion are applied with some level of potentially destructive compression. Essentially, this means that if files are saved and opened frequently, some data is lost and files are steadily degraded. Saving to a CD or DVD, so the data remains unaltered, can compensate for this.

Pixel Count. Each of the three JPEG compression levels are associated with a pixel count. With a 6-megapixel camera, the maximum resolution is 3024x2016 (fine/best setting setting). The normal/better resolution is 2304x1536 pixels (3 megapixels), and the basic/good setting is 1440x960 (1.5 megapixels). Digital cameras allow photographers to select from three levels of compression: basic/good is a high-level compression, normal/better is a medium-level compression, and fine/best produces the lowest level of compression for better image detail.

The advice here is, if using JPEG mode, avoid opening and saving the file more than once or twice, and if saving in JPEG, always choose a low-compression save (level 10 or 12 in Photoshop). The sample images shown on the facing page illustrate the destructive nature of the "lossy" format.

JPEG allows the user to take photographs in succession more quickly than using the other modes and does not require images to be reprocessed after downloading to the computer. They can be worked on to your heart's content as soon as they are opened in Photoshop. JPEG files also take up less space on your memory card, allowing substantially more images to be stored than in any other format. Typically a 6-megapixel camera will store high-quality JPEG files at about 2MB in size.

JPEG allows the user to take photographs in succession more quickly than using the other modes.

TIFF. During capture, TIFF files can be considered for all intents and purposes to be similar to JPEG files, but they are generally not compressed (although they can be in certain instances) and retain all of the image data no matter how often they are saved and opened in Photoshop. Compared to JPEG files, TIFF files take longer to process and are much larger, meaning that fewer images can be saved to the memory card. A typical TIFF file from a 6MB camera might be around 5MB in size. Though working in TIFF format in Photoshop has some benefits, there is little benefit in shooting in this mode in camera. Though there is no compression applied to the saved file, the potentially destructive conversion of white balance, contrast, etc., is still applied. The increased popularity of RAW mode shooting and similar file sizes has led manufacturers to eliminate the TIFF capture mode on some makes of camera.

RAW. Unlike JPEG files, RAW files are captured at full resolution but in some cases (like the Nikon D2x) can also be compressed.

RAW is the favored format for those who want only the best in quality and flexibility from their images. Unlike JPEG and TIFF files, RAW files are not processed into finished files in the camera. Instead, the image data is saved into separate channels of information (sharpening, contrast, saturation, white balance, etc.). Once the files are opened in a RAW file processing program (such as Adobe Camera Raw), the various settings can be adjusted to achieve optimum quality at a lossless level. Because RAW files contain a great deal of image data, they are very large. Also, because they must be finessed in post-capture, the wedding photographer with several hundred images to tweak is faced with a daunting task. A chart comparing the file sizes for several mainstream cameras is shown on the following page.

Enlargements from the original file (top) showing a PSD file (bottom left) and JPEG file (bottom right) with artifacts and break up of the original file.

Image File Size at Maximum Resolution				
CAMERA	*(PIXELS)*	*JPEG*	*TIFF*	*RAW*
Nikon D70s	(6.1 MP)	2.9 MB	not available	50MB
Fuji S2 Pro	(6.17 MP)	6.17 MB	35.5MB	12.4MB
Canon EOS 5D	(12.8 MP)	12.8 MB	not available	12.5MB
Nikon D2x	(12.4 MP)	12.4 MB	36.5MB	12.6MB

So what do we use, and when? To my mind, there is little benefit in shooting in TIFF mode under any circumstances. The uncompressed TIFF files offer a larger file size than do the low compression JPEG files, but you've got to consider the fact that shooting TIFF slows the operating speed of the camera. If the image is shot in JPEG and then saved on the computer as a TIFF (or better still a PSD [Photoshop] file), there is no noticeable loss of data, you can store more files on your memory card, and can shoot faster sequences if need be. The drawback of shooting in either TIFF or JPEG mode is that you have to get it just right. There is little margin for error, as we will discuss in chapter 3.

Shooting in RAW mode will give you more flexibility with high quality, even if you are able to store fewer images on the card and have to process the data later. Any mistakes in exposure at the time of shooting can, to a certain extent, be rectified in postproduction without degrading the image quality.

The main disadvantage of this method is the time required in postproduction. Some manufacturers have tried to address this problem by allowing simultaneous capture of RAW and lower-resolution JPEG files. This allows speedy access to JPEG images for proofing but the retaining the more versatile RAW images for final output.

We will discuss this further when we look at camera settings in detail, but the rule of thumb is, if you are sure of your exposure (e.g., in the studio when the lighting is constant and you know the limits of your equipment), there is nothing wrong with JPEG capture. Excellent 30x40-inch wall portraits are possible through this method of working. When shooting weddings or portraits, my preference is to capture exclusively in RAW because it is much more forgiving. In changeable and difficult lighting conditions, your clients do not want to see you fiddling with equipment. It's more important to concentrate on your subject and to capture the moment. When we look at workflows, we will delve into the mysteries of file conversion and how to speed it up, making it a much less painful experience.

Shooting in RAW mode will give you more flexibility with high quality.

Color

Some high-end digital cameras offer a color mode to control saturation of colors. Not to be confused with color temperature, which pertains to the white balance settings, the color control affects the strength of the color density (its saturation) that the camera produces and usually has three levels

of low, medium, and high (off, standard, hard, etc). Setting this control too high can produce strong color casts that prove difficult to remove later on.

Tone

This control allows the user to select a low, medium, or high level of contrast within the captured file.

As camera manufacturers get ever more proficient at designing the products and software, additional options become available. Some cameras offer color and tone options that mimic results produced with Kodak, Fuji, and Agfa film emulsions. This allows photographers to create more saturated images for landscapes or smoother skin tones for portraiture.

Sharpness

In general, a film image is either sharp or it's not; there is no middle ground. All digital images, however, require some degree of sharpening to counteract the effects of interpolation by the camera software. The amount of sharpening needed greatly depends on the subject matter, tone, color, and other algorithms applied to the captured image. This correction can usually be applied in three levels, much the same as color and tone can.

Note that oversharpening can result in jagged outlines or artifacts on the boundaries of high-contrast areas.

Oversharpening can result in jagged outlines or artifacts on the boundaries of high-contrast areas.

Exposure Value (EV) Compensation

Exposure value compensation (EV) affects the under- or overexposure of an image relative to the "correct" exposure calculated by the on-board metering system. The process of using this control is much the same as under- or overexposing film but is much more critical. This will be detailed in chapter 3.

In most professional cameras, EV control can be applied to compensate for both ambient and flash separately. The degree of control varies from camera to camera but can generally be applied in either $\pm\frac{1}{3}$ or $\pm\frac{1}{2}$ stops.

Before we choose our camera settings for the various control modes, we must first have a basic understanding of how the camera deals with our images. The basic theory that follows is not rocket science, so bear with it. Though not essential, it will help you understand why we make the choices we do.

CHAPTER TWO

EXPOSURE

By adjusting your aperture and shutter speed, you determine the amount of light that strikes the image sensor. A good exposure will produce an image that accurately reflects the scene being photographed. Too much light will cause the image to be overexposed, and too little light will result in underexposure.

When printing film, a lab technician could make adjustments to the filtration or the length of time that the image was exposed under the enlarger. Inconsistencies in exposure went relatively unnoticed by the photographer.

Though exposure has always been important in getting the image just right, you'll need to work a little harder to achieve good exposure with digital. Digital capture is more akin to transparency film than negative film; you should expose to preserve detail in the highlights.

The diagrams below compare the exposure latitude (x axis) and quality (y axis) of a good negative film with today's image sensors.

The first diagram (film) indicates the "perfect" exposure and quality at point 0 with an acceptable image able to be produced at approximately 3 stops over and 2 stops under (supporting the commonly held belief that film has approximately a 6- to 7-stop exposure latitude). Though film can be push processed and images can be produced outside of this range, they would not be considered acceptable due to the amount of grain, contrast,

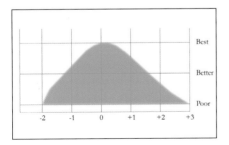 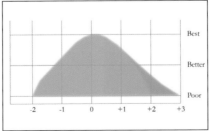 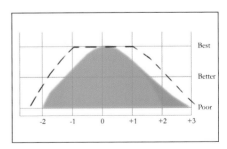

Left—Idealized film latitude. **Center**—*Digital JPEG latitude.* **Right**—*Extended latitude of digital RAW.*

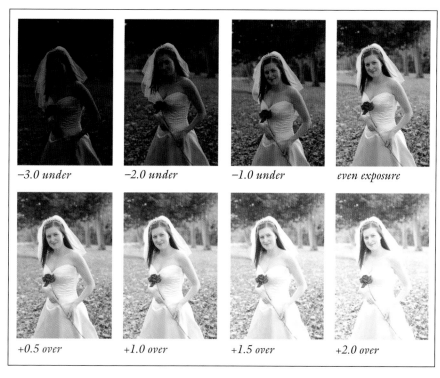

−3.0 under −2.0 under −1.0 under even exposure

+0.5 over +1.0 over +1.5 over +2.0 over

Digital capture has the equivalent of a 4- to 5-stop latitude at best (1.5 stops over and 2 under).

and loss of detail inherent in the latent image. We are assuming that the film has been exposed and developed in line with the manufacturer's intentions.

The second diagram (JPEG capture) indicates the limits of most modern image sensors, with "perfect" exposure and quality again indicated by point 0. We can see how quickly we run into trouble when we don't get the exposure right. Digital capture has the equivalent of a 4- to 5-stop latitude at best (1.5 stops over and 2 under). Beyond this, the resulting prints are not acceptable. In some cases, we could probably get away with pushing the exposure (e.g., creating a moody black & white image with plenty of grain given the right subject), but this is the exception rather than the rule.

The third diagram (digital RAW) shows the extended latitude that postproduction work can give. Though the exposure latitude that we can achieve an acceptable print from is still only 3 stops, the point at which exposure is "perfect" can vary by up to an additional stop under or over. Unlike other capture formats, the RAW image is not set in stone at the click of the shutter button—it can be reset during postproduction.

We can see yet another advantage of the exposure latitude of RAW files in the third diagram. When shooting in RAW, we can intentionally underexpose the image slightly to preserve detail in the highlights. We can then lighten the midtones and shadows in postproduction. This allows us to prevent a loss of detail in the lace and reflective areas of the bride's gown.

The images above demonstrate problems common to digital exposure. The following JPEG images were captured on a Nikon D2x camera. The built-in meter was allowed to calculate the exposure, then EV compensation was made to simulate under- and overexposure. No flash was used, and none of the images were adjusted in Photoshop. Detail is just disappearing in the

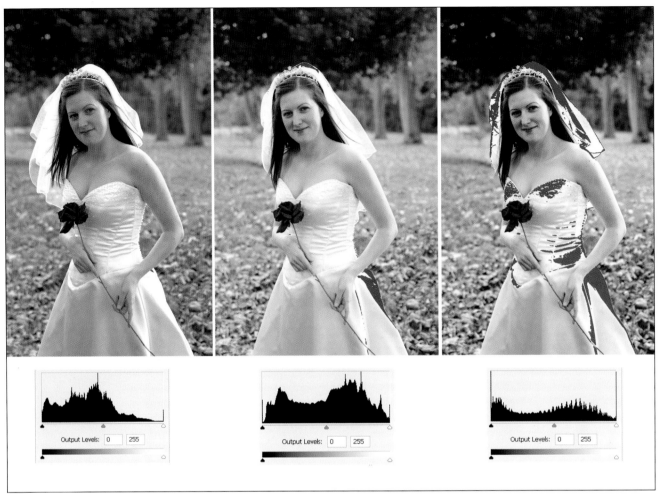

Left— −2.0 *stops underexposed JPEG corrected in Photoshop. All the shadow and highlight detail has been held although the image is slightly lacking in contrast.* *Center—* +1.0 *stop overexposed JPEG adjusted in Photoshop. Red areas show clipped highlights with no detail.* ***Right—*** *+2.0 stops overexposed JPEG adjusted in Photoshop. Highlights have been totally clipped and shadow areas are losing definition.*

image that is +0.5 over but acceptable. Even at +1.0 stops overexposed, image detail has been clipped, and we are getting into trouble with exposure very quickly.

Now compare the images on the facing page, which were equally over- and underexposed in the camera but captured in RAW format. The images were adjusted in Adobe Camera Raw, showing that detail can easily be retained in images at either end of the exposure range. From −4.0 to +2.0 equates to a 7-stop latitude, which is pushing it a bit, and although satisfactory images can be made from severely under- or overexposed files, noise will inevitably creep in at extreme latitudes. The accompanying histograms also show the increased amount of image information that has been retained in the RAW files over the JPEG images.

We can also use the flexibility of the RAW format to shoot high-contrast scenes that extend beyond the normal range of capture by processing a chosen image for highlights, then processing a second copy of the same image for the shadows, and combining the two exposures in postproduction.

Part of the reason for the so-called extended exposure range of RAW is due to the way in which cameras handle the files at capture. If the camera is set to JPEG mode, the image is converted to the camera software's 8-bit conversion mode, giving only 256 levels of brightness. When the camera is set to RAW mode, the image is not processed and remains in 12-bit or 14-bit mode (depending on camera make); this accounts for its larger size. If the camera's RAW mode is equal to 12 bit, then there are 4096 levels of brightness. The RAW file is only reduced to 256 levels of brightness when converted after adjustment to give an optimum image. RAW images can also be converted to 16-bit files, giving even greater levels of brightness adjustment; however, the images will still need to be converted to 8-bit files prior to printing.

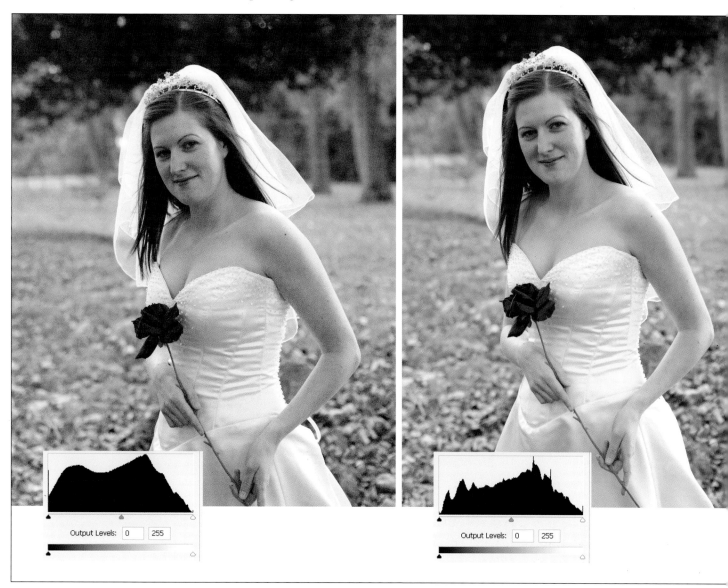

*Left— –4.0 stops underexposed RAW image converted in Adobe Camera Raw. This will make an acceptable print with minimal noise. **Right**— +2.0 stops overexposed RAW image converted in Adobe Camera Raw. Note the fully developed histogram.*

Relative Brightness Levels

DYNAMIC RANGE	12-BIT RAW FILE	8-BIT JPEG FILE
1st—brightest tones	2048 levels	69 levels
2nd—bright tones	1024 levels	50 levels
3rd—midtones	512 levels	37 levels
4th—dark tones	256 levels	27 levels
5th—darkest tones	128 levels	20 levels

The table above shows the relevant brightness levels assigned to RAW and JPEG files, assuming a 5-stop dynamic range.

In the RAW format, even in the dark tones of the image, we have as many brightness levels as the whole of a JPEG file. You can imagine even with some moderate adjustment in Photoshop that the JPEG image will be destroyed in no time at all. Instead of smooth transitions in exposure, we get posterized and noisy images.

Allow me to reiterate at this point that if the JPEG image is correctly exposed, there would be no difference in the two files once the RAW file was processed and converted, and each one would hold up perfectly during printing.

With moderate adjustment in Photoshop the JPEG image will be destroyed in no time at all.

HISTOGRAMS

Everyone knows that histograms give an indication of over- or under-exposure, or do they? Whether viewed on the back of the camera or in Photoshop they both tell you essentially the same thing, but what?

It's important to understand that computers and cameras do not see color, only numbers. Values of 0, 0, 0 (black) in the Red, Blue, and Green (RGB mode) channels produce black, and values of 255, 255, 255 in the same channels produce white. By combining those colors in slightly different amounts, you can create over 16 million colors.

Let's look at a simple mosaic. There are 256 tiles in the mosaic with each tile made up from a single color (87 dark blue, 10 brown, 7 red, 34 green, and 118 light blue). If we stacked each tile of the same color vertically and looked at them from the side, they would look like the photo below. The resulting "histogram" shows the distribution of colors in the mosaic, with the light blue pile the highest, and the lowest pile representing the red tiles.

So our histogram does not indicate exposure but merely the distribution of color within a given image, represented by vertical columns. The height

Our histogram does not indicate exposure but the distribution of color within an image.

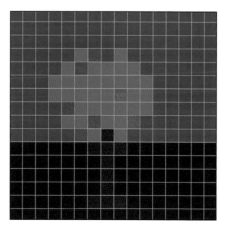
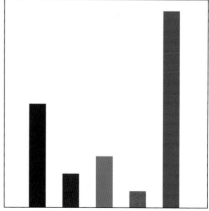

Left—Photographic "mosaic" of a cherry tree. Right—Histogram of a cherry tree mosaic.

A "correctly" exposed image (left) and a histogram of a "correctly" exposed image (right).

The image and histogram above show "clipped" shadow detail.

of each column represents the number of pixels corresponding to a particular color in the image. The pixel columns are arranged in order into 256 levels of brightness between 0 (black) and 255 (white).

Now let's look at how we can examine the histogram to give us an indication of exposure. When we look at a histogram for a "correctly" exposed image (whether on the camera or in the Levels palette in Photoshop), it might look like the one above, showing the combined channels (RGB) in a single graph with 0 (black) on the left and 255 (white) on the right. The data grows steadily from the left-hand edge of the graph at the shadow end, rises and falls depending on the color information in the image, and descends steadily to the highlight end of the graph at the right.

The trick is to have the histogram extend as far to the left and right of the graph as possible without peaking at either 0 or 255. This histogram shows that the sample image displays all the subtle details contained in the highlights and shadows and has "good" exposure.

If we look at the following image and accompanying histogram, we can see peaks at the shadow end of the graph. If these peaks occur, the color information is said to be "clipped." In other words, the shadow areas are blocked up and when printed will appear black without detail.

We should, however, be very careful in assessing exposure from the histogram. If we look at the low-key histogram, it looks as though there is not much detail in the highlight areas of the image; the peaks are concentrated

right over to the left-hand side of the graph, indicating that it may be underexposed. Of course, this is what we want to see in this case, as the associated image is actually low key.

If we look at the histogram for a high-key image, we will see that most of the tones in the image fall toward the right (or highlight) edge of the graph. This is desirable in this case, as we expect our high-key image to be comprised mainly of light tones.

To summarize, then, histograms can be confusing and should not be relied upon for determining exposure; they only show color pixel information. Certainly, at the capture stage, you should be aware of what to expect depending on your shooting situation. Face mask histograms are a better indicator of correct exposure; in chapter 13, we will look at how they can be used to analyze your images.

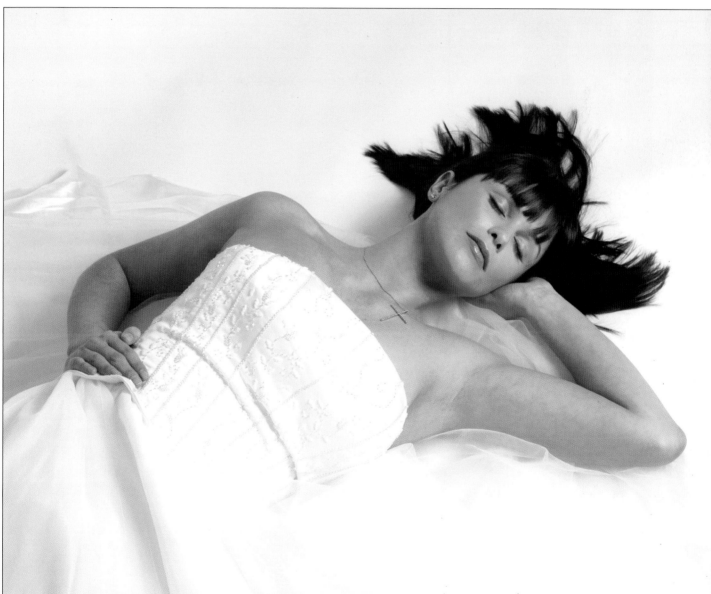

The image and histogram show clipped highlight detail.

Histograms are also useful for indicating the relative contrast range of the image. If we look at the histogram for the wedding gown image, we can see that both the highlights and shadows have been clipped. This indicates that the image exceeds the dynamic range of the camera and has too much contrast. In such a case, fill flash can be used to compress the tonal range of the image to within the camera's limits.

The image of the place card shows plenty of midtones but few highlights and shadows, indicating a file with too little contrast. This could also be corrected by use of fill flash, but the available contrast range can be stretched by moving the shadow and highlight sliders to meet the ends of the histogram.

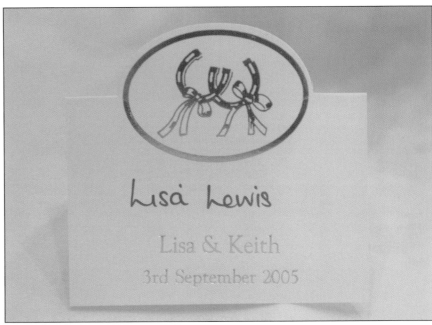

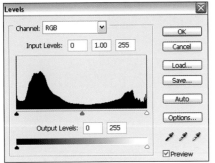

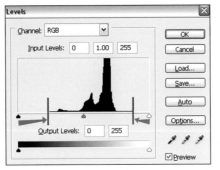

Top and bottom left—The histogram from the high-contrast image, showing clipped highlight and shadow detail. ***Top and bottom right****—A low-contrast histogram. The image can be corrected by dragging the shadow and highlight sliders below the edges of the histogram data, as shown here.*

CAMERA SETTINGS

To ensure that we can capture the desired tonal range in the image, we need to adjust our camera controls to a failsafe position, ensuring that we only need to make minor adjustments during the photo session. Remember that your clients pay the bills; you should devote most of your attention to them, rather than to the equipment you're using.

Factory Defaults

Normally the new camera will arrive in its box, programmed with factory defaults that allow you to put in the batteries and start shooting. This, however, will not yield the best results. The following suggestions are based on the settings I use. This should be the subject of your own testing, however, as all equipment, studios, and subjects are not the same and require experimentation. Nevertheless, these guidelines offer a good starting point.

Preferred Settings

All professional cameras allow you to control the functions that affect quality. They will not be in the same location on every camera, but they can be accessed through menu functions or dedicated scroll wheels.

Lighting conditions are constantly changing throughout the day, and with today's modern photojournalistic approach to many weddings and al fresco portraiture, we rarely get the chance to change camera settings as quickly as the weather changes. It would therefore be nice to configure the camera to give us the greatest latitude for correction should we misjudge general settings. This means shooting in RAW.

You may need to refer to your camera's handbook to find out how to activate this function, but once you do, use this setting throughout the photo shoot. You could in theory leave all the other settings alone and adjust them in postproduction, but we do need to capture the image as close to perfect as we can to give us a fighting chance when the unpredictable happens.

All professional cameras allow you to control the functions that affect quality.

Let's start making our image control adjustments as discussed in chapter 2. We are going to change the capture mode to RAW, so find the adjustment for the white balance and set it to Auto. This setting will work for most, if not all, of your shooting situations. Some settings such as Cloudy may work better indoors, but we can correct the white balance at a later point in our workflow.

Next, let's look at the compression level setting (sometimes referred to as the "quality" of the image). If you want the best images, then there is only one setting to use—the highest. Usually, when the RAW mode is selected, the image is automatically captured using the highest-possible pixel count; however, if shooting in JPEG, you may need to manually select this option. You never know what your customer will order—perhaps an 8x10- or maybe a 30x40-inch wall print—so select your highest pixel count.

Next, we'll turn our attention to the color, tone, and sharpness settings the camera applies to the image. Most manufacturers set these at the midpoint or average of the camera's capabilities; however, I would urge you to turn them to the lowest setting or off. In chapter 3 we discussed the problem of adding too much contrast. The same problems occur when adding saturation (color) and sharpening. By turning these additive functions down or completely disabling them on the camera, we have a cleaner image to build on—and again, we can adjust the image in postproduction. We will discuss color management in chapter 6, but for now, note that if you have an option to set the color space of your camera's capture mode, use Adobe RGB instead of sRGB because of the larger color range that the former mode can capture.

The remaining photos show the finished settings applied to these controls on the Nikon D2x. None of these controls need to be changed at any time during the shooting process. Note that, for comparison purposes,

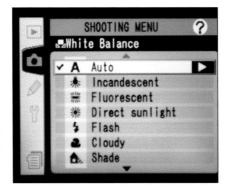

Top left and right—White balance and RAW (quality) settings in the camera menu. *Center and bottom rows*—Additional capture settings accessed through the menu of the Nikon D2x camera.

Camera Settings for the Fuji S2 Pro

CONTROL	SETTING	FUNCTION
white balance	Auto	automatic white balance control
capture mode	High	sets camera to RAW or TIFF mode (additional changes must be made via the menu)
pixel count	4256	highest pixel count
color	0rg	turns saturation off
tone	0rg	turns contrast control off
sharpening	0rg	turns sharpening algorithm off

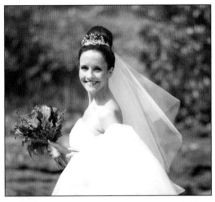

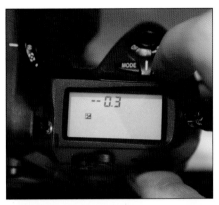

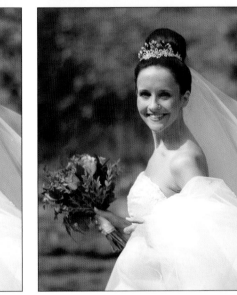

Left column—Wedding dress has clipped highlights (top) but has been compensated for by –0.5 EV adjustment (bottom). **Right column**—*Setting EV ambient compensation on the camera (top). Final adjusted image (bottom).*

the settings for the Fuji S2 Pro are shown in the table above.

Because on-board camera metering systems are designed to read "average scenes," they fall short of getting correct exposure in some situations. As handheld meter readings are generally slow (although more accurate), it would be nice to modify our camera settings to cater to scenes that are not "average." Although not all brides wear white, this is generally the case, and the dress is in most cases highly reflective. Position the bride against dark foliage or in a room with low light levels, and the camera's metering system will tend to want to brighten the overall scene (unless it's spot metering), eventually clipping the highlight details. The same is true of grooms with dark suits and white shirts. Because the majority of the scene is darker than average, the camera will overexpose the image in order to bring out the details in the suit, consequently blowing out any texture in the subject's white shirt.

We can see that the straight capture image (top left) has clipped highlights with no detail in the brightest parts of the dress. The final image (bottom left) shows the result of compensating for this by adjusting the ambient EV. Making an adjustment of $-\frac{1}{2}$ or $-\frac{1}{3}$ stop will compress the highlight range of the histogram in order to ensure that the lightest tones of the image are not blown out.

The compensation does cause a slight loss in the contrast range, but because we can make fine adjustments in the RAW conversion of the image, we can pull the contrast range and brighten the image by adjusting the Exposure and Temperature sliders until the tail of the highlight in the histogram

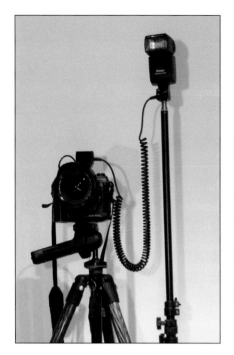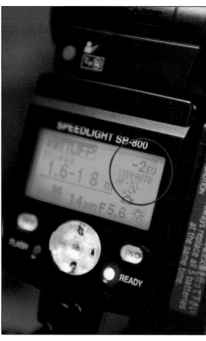

*Left—Example of off-camera flash and a dedicated sync lead. **Right**—EV flash compensation set on the flash unit at −2.0 stops.*

almost reaches the 255 end of the graph. The final adjusted image is reproduced on the previous page (bottom right).

Some meters are better than others, and the degree of accuracy cannot be generalized, so this is my advice: choose the best settings by experimentation and remember that digital capture handles shadow detail better than film, so use this property to your advantage. This technique also works for the average scenes that do not seem to be overly affected by the reduction of ambient EV, meaning that it can be set once and left, without determent to any of your images no matter what the lightness levels or tonal range of the scene.

Fill Flash

Using reflectors to control light in the shadow areas for individual portraits is a great way to model the light around your subjects, but there are times when fill flash techniques are required.

Using individual power packs or strobes connected to the mains usually demands separate handheld metering to balance the main light (ambient) with your flash (fill light), particularly for those photographers who tend to use several flashes to control all of their light. This is akin to working with studio lighting setups, and metering patterns are generally no different.

Using off-camera or tethered flash is a technique employed by many photographers; it allows a degree of control that is fast and flexible without the need to take additional meter readings.

Professional cameras will allow the additional setting of EV compensation for flash. Differing manufacturers of flashguns allow the use of through-the-lens (TTL) metering, which is crucial to this technique, but again, read the manual for the individual units. It's too easy to select what you think is the right setting and find out at some critical stage that there is more than one

Using off-camera or tethered flash is a technique employed by many photographers.

TTL setting depending on which camera the flashgun is attached to! Choose a TTL setting that will allow EV compensation and test it by changing the setting to overexpose and underexpose and compare the results.

With the flash set to TTL metering, adjust the flash EV compensation to mimic the settings you might use in the studio (e.g., adjust the fill flash to between 1 or 2 stops under the main [ambient] light source to fill in the pockets and sockets). Remember that we have already adjusted the ambient EV to about –0.3, so the flash will need to be set to –1.3 for one stop less or –2.3 for a 2-stop adjustment. This flash adjustment is made on the rear display of the digital flash unit but may also be available on the camera. Do not apply the adjustment in both camera and flash simultaneously or unpredictable results will occur.

This is a general assumption based on an average scene. If your scene is backlit, then your metering will assume your "average scene" is overexposed and want to lower the exposure. This is fine for the background area but no good if you don't want your subjects in near silhouette. The answer is to adjust the flash to deliver an extra half stop. (Use an EV compensation of –1.0 instead of –1.5 without adjusting the EV ambient compensation.)

In order to get the best results from your fill flash technique you will need to set your flash sync speed to "slow." This has the effect of dragging the shutter, allowing the camera to expose for the ambient condition and just fill the pockets and sockets with a little sparkle, which won't overpower the image.

Do not apply the adjustment in the camera and flash simultaneously or unpredictable results will occur.

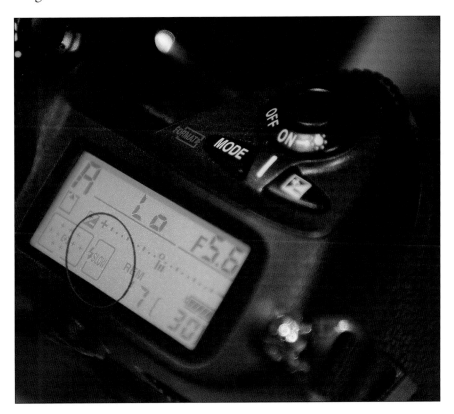

Flash synch set to Slow on the camera's top plate.

WORKING IN JPEG

As cameras get ever more sophisticated and metering systems become more accurate, photographers will learn to rely on their equipment to get the image right in JPEG mode, eliminating the need to add an extra processing stage between capture and output. In chapter 2 we demonstrated how RAW capture has an advantage over JPEG when it comes to capturing quality images, but when the images are processed as 8-bit files, they have exactly the same properties as a native JPEG.

So if we can control the conditions under which we shoot and do not need to work at such a frantic pace, we should be able to capture a successful image in JPEG without compromising quality.

Working in the studio gives us our greatest chance of success. The light conditions for a given setup remain constant, removing the variable fluctuations in brightness, tone, and contrast. The first image in any given series can be checked immediately (much the same as Polaroid proofing) to ensure the remaining images for the lighting set will be consistent. Camera setup is then relatively straightforward, giving dependable results every time.

The image sensor in your camera may be manufactured in an assembly line, but it is essentially hand made. This leads to variations in build that give each camera its own "personality." Having undertaken tests with two identical cameras using the same capture card, lens, and camera settings, the results were surprising. The two JPEG control images were visibly different! When I queried the manufacturer, they agreed that they too saw a difference, but also stated that the images were "within expected tolerances." You can make up your own mind as to what that means!

This observation demonstrates that each of your cameras will differ to some degree, but the variations can be taken out to get more of a consistent result by using a custom white balance. In RAW format this becomes unnecessary due to the fact that the images are post-processed anyway, but in JPEG for high-quality work it is essential.

...we should be able to capture a successful image in JPEG without compromising quality.

The custom setting is usually selected through the main menu controls of the camera. (Consult your camera's manual.) The method described here is generalized so that you can follow the process, but will not vary too much between camera models.

The custom setting is usually selected through the main menu controls of the camera.

1. Meter your lighting setup and set controls on your camera in manual mode.
2. Change the camera to manual focusing mode rather than auto (you can change it back later). Use a large sheet of pure white board (2x4 feet) or an expanded polystyrene sheet and place it in the main position where your subject(s) will be, then select the Cus1 setting in the camera menu, and it will ask you if you want to set it. Press OK to confirm.
3. Manually focus on the edge of the white board, fill the viewfinder with the board, and then press the shutter. If your camera was left in auto-focus mode, the lens would "hunt" unsuccessfully for a focusing point and not make an exposure.
4. You should have a pure or near white image on the camera's LCD screen. Press OK to confirm the setting and check the image in the back of the camera while bringing up the histogram. You should see something like the image below. If so, you can reset your focusing mode to auto.

The histogram should look flat apart from a spike in the far right-hand side, indicating a good white balance. If the spike is not over to the far right of the histogram, then you should adjust your lighting to give a little more illumination or make changes to your aperture setting and run through steps 1–4 again.

Although faint, the custom white balance "spike" can just be seen at the far right of the histogram on the camera's LCD screen.

We can now select the Custom setting in the white balance menu in the normal way and we're ready to go. The images we capture during our shoot should be almost perfect with very minor changes required in the processing stage. The only time you need to repeat the custom white balance process is if you change your lighting ratios or positioning.

Some manufacturers, such as Lastolite, have come up with a new target called a gray balance. The method for setting this custom balance is the same as described above—the only difference is the position of the spike(s) in the histogram. The target (shown below) is provided by Digital Photo Solutions and measures approximately 6x6 inches. When the resulting image is analyzed with the correct settings it will produce a histogram similar to the one below. Each spike represents the white, gray, and black areas of the target.

In the next section, we are going to look at various ways of postprocessing RAW and JPEG files to get the optimum image for printing.

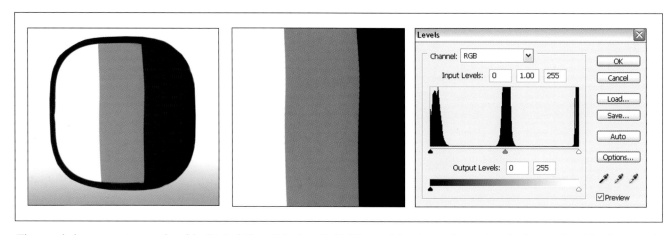

The gray balance target as produced by Digital Photo Solutions (left). The resulting image (center) and spikes produced by the target in the histogram (right).

COLOR MANAGEMENT

There is much confusion over the concept of color management. To try and dispel some of the myth and misinformation, a close colleague, Mike McNamee—editor of *Professional ImageMaker* in the UK, and an experienced lecturer, profiler, and scientist—and I combined our insights to provide a serious and extensive investigation of color space workflow.

Why color manage? The object is simple: to get what you see on the screen to match your intended output. The difficulty is that a manufacturer's equipment is device independent, which means that getting one piece of equipment to talk to a piece of equipment made by another manufacturer is not always straightforward.

Flowchart describing the color management process.

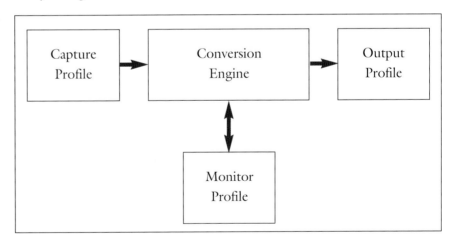

A camera's color profile is assigned by its manufacturer to convert the light captured by the sensors into data (the capture profile). This data has to be transformed by a conversion engine in a software program on the computer (Adobe Photoshop) to show the colors on the monitor. The only way we can be sure of the colors being shown on the monitor correctly is by calibrating it. X-rite, GretagMacbeth, and other manufacturers produce equipment that generates another code (the monitor profile) that is assigned to the mon-

itor that you view your images on. Finally, the monitor profile is transformed by the conversion engine to an output profile that matches the color characteristics of your printer (or external lab).

By calibrating our color profiles, we can ensure accurate color matching throughout the workflow process. Although manufacturers design profiles to put their equipment in the right ballpark, there is no substitute for profiling your own equipment and workflow. The better the profile, the better the result. However, there is a balance to this equation, and this is the color space.

Many photographers do not understand the relationship between color space and profiling. Profiling determines the accuracy of your capture, manipulation, and ultimately your output. The color space (or gamut) is the amount of available colors that can either been seen (monitor color space) or output (printer color space).

Though there are other color spaces, we will consider only two, sRGB and Adobe 1998, in this book.

By calibrating our color profiles, we can ensure accurate color matching throughout the workflow.

sRGB

This is the most common color space, originally promoted by Microsoft and other PC manufacturers, based on the expected quality of an "average" consumer viewing a PC monitor. It has also become the standard color space of all consumer-based digital cameras and scanners. It was designed to have a low color gamut best suited for use on the Internet and for viewing on monitors with unknown or poor viewing characteristics.

Adobe RGB (1998)

The RGB 1998 color space was developed by Adobe as a recommended standard for images that will be converted to CMYK for printing. Though the color gamut is still relatively small, it provides the best compromise between quality and gamut size.

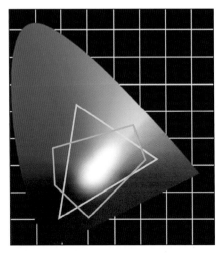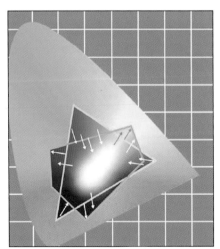

Left—The visible spectrum (solid color) and relative space of Adobe RGB 1998 (yellow triangle) with CMYK printing gamut (blue).
Center—Diagrammatical substitution of color when moving from one color space to another. **Right**—*Three-dimensional representation of Adobe RGB 1998 color space (indicated by dots) and sRGB color space (solid).*

Though there are other color spaces that offer greater color gamuts, they include a lot more colors than can be viewed or even printed. There is therefore no point in working these color spaces just to throw the information away when printing. To get the best out of these color spaces we need to be operating in 16-bit mode, which increases our file sizes and slows down speed of operation.

Having worked in both color spaces, we found that there was no discernable difference in the output when working in either sRGB or Adobe RGB. So, if the output results were so similar, why all the confusion?

The human eye is capable of discerning a wider color gamut than the CMYK and RGB gamuts and can perceive three dimensions. Also, though we can perceive three dimensions, three dimensionality is hard to represent on a two-dimensional page. The conversion engine has to map the colors captured in camera into the available gamut of the monitor for editing and manipulation, then remap the colors again into CMYK for printing. We can see that some colors do not transfer easily from one space to another and end up getting converted to other colors that are available, or worse still, thrown away. In this regard, it is better to use the largest availabel color space for capture so that fewer colors get remapped during processing further down the workflow chain. The diagram (facing page, right) shows the available Adobe 1998 (RGB) color space and sRGB color space in three dimensions, showing that Adobe has a larger color space than sRGB.

It appears that problems occur when workers do not "honor" the workspace. In other words, if you capture JPEGs or scan the image using the sRGB workspace, then you should not convert the image to Adobe 1998 or likewise, from Adobe 1998 to sRGB. The real problems occur if images are captured in sRGB on the camera, converted to Adobe 1998 in Photoshop for manipulation, then back to sRGB for printing.

Working in RAW mode capture is relatively straightforward as no color space is assigned to the image until it is processed. We can therefore assign sRGB or Adobe RGB depending on the remainder of our workflow.

In the past, color management has not been easy to understand or implement; however, with an ever increasing number of people embracing the digital revolution, equipment manufacturers, photographers, and printing labs are understanding the need to standardize and embrace the need to calibrate, profile, and take the necessary steps to ensure good workflow from beginning to end.

We can see that some colors do not transfer easily from one space to another.

Setting Up Photoshop

Some photographers use Photoshop without altering its default settings. However, changing some of the preferences will give you an edge.

Edit>Preferences>General will get you into the dialog box shown on the next page, and several changes can be made. The History States usually defaults to 20 and refers to the number of "undo" commands you can apply.

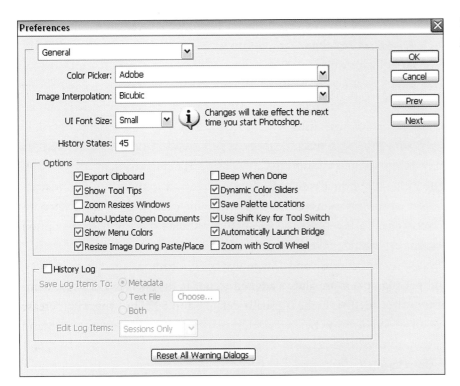

Top—*The General Preferences dialog box.*
Bottom—*The new Adobe Bridge interface.*

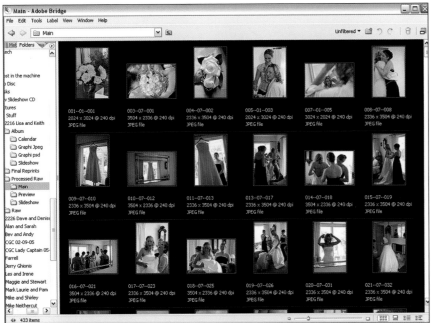

This is usually too small to be of any real use, so increase this to 45. You can set it at up to 1000, but this will just fill up the hard drive with all the previous versions of the file and slow down the computer.

Adobe Bridge is one of the most useful additions to CS2 and is worth the price of the upgrade alone. It's worth clicking the check box to Automatically Launch Bridge each time Photoshop is opened.

Change the General tab to the next on the menu, which is File Handling. Change the Maximize PSD and PSB File Compatibility to Never. These file types save all the layers that make up the image, but if the option is left

unchecked, it also creates a flattened image, which is saved with the layers for use in programs that cannot handle layered files but understand the PSD format. The resulting files are therefore much larger.

Move on to the Plug-ins and Scratch Disks menu. A scratch disk is a part of the hard drive that keeps track of the changes in your active files and allows you to undo the History and of course redo it. If the disk becomes full, it will slow down the machine or even prevent you from doing anything in Photoshop. The answer is to shift the processing to other drives on the computer when the primary disk becomes full. You can choose up to four separate hard drive locations. Closing the active file will release all the cached information and allow you to start over again should you not have the option of using additional drives.

Now select Memory and Image Cache. Photoshop is memory hungry, and photographers are always advised to put in as much RAM as the computer will hold. This cache is usually defaulted to 50%, but you will increase the speed of operation by increasing it to 80%. As long as you do not intend

Shift the processing to other drives on the computer when the primary disk becomes full.

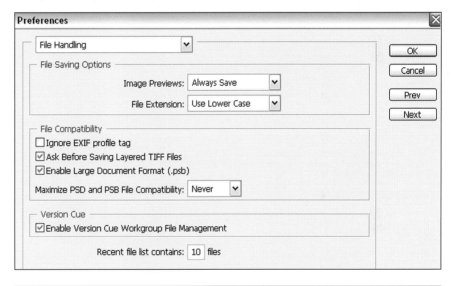

Top—*The File Handling dialog box.* ***Above***—*Choosing additional scratch disks.*

to do too much multitasking, the computer will manage with the 20% left for other vital operations.

Close the dialog box by clicking OK and open Edit>Color Settings using the drop-down menu. This is where we select our color management options. The Working Space should be changed to Adobe RGB (1998), and you should turn off the Profile Mismatch check boxes. Photoshop will not warn you about color-related issues unless it's necessary (such as a missing profile).

Now we can close the dialog box by clicking OK. The changes we have made will not be active until we have closed down Photoshop completely and opened it again.

Photoshop will not warn you about color-related issues unless it's necessary.

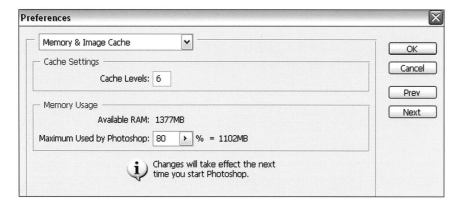

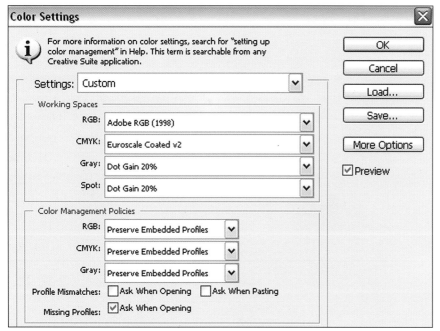

Top—*Speeding up Photoshop by increasing memory allocation.* ***Above***—*Finalizing your color options.*

PROCESSING RAW FILES

Although shooting JPEG is an option, we have demonstrated the flexibility of RAW files, and this shooting mode is equally at home in the studio as at a wedding. Let's look at processing a sample set and some of the tools that help us do this quickly and efficiently.

One of the most useful tools for shooting in RAW mode is the GretagMacbeth ColorChecker.

One of the most useful tools for shooting in RAW mode is the Gretag-Macbeth ColorChecker color rendition chart. It consists of 24 accurate color squares, which have known values. (Remember that the computer sees color as numeric values.) The value of these squares is generally expressed in Lab mode (Lightness, a, and b channels) because Lab color is device independent and is the same no matter what color space we are working in.

Depending on the anticipated use of your image (web or print; see pages 35–37), you'll select either the sRGB or Adobe RGB color space. The actual

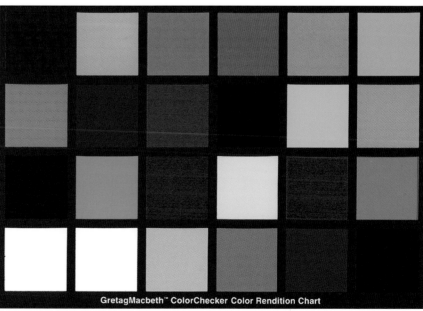

GretagMacbeth™ ColorChecker Color Rendition Chart

The GretagMacbeth ColorChecker Color Rendition chart.

value of these squares will change depending on the color space of the monitor, but we will assume for the remainder of this book that we are working in the Adobe RGB (1998) color space.

The most important of these colors is the gray set at the bottom of the chart. We'll worry about the numbers later, but for now let's go back to the camera settings. Because we are going to use the ColorChecker and shoot in RAW capture mode, there is no need to set a custom white balance on the camera. This means we can use our "standard" settings for RAW shooting. When shooting in the studio, the only change needed would be to remove the ambient and flash EV compensation.

Our first step in the capture process is to take a reference image with the ColorChecker in the shot, then to remove the card from the set and carry on shooting the remaining images. Shooting outdoors with the ColorChecker in every scene at a wedding would be a bit tedious, so we will discuss this workflow later.

The following images were shot using an Olympus E1 Pro camera in under ten minutes with mismatched lighting units and an assortment of light

Our first step in the capture process is to take a reference image with the ColorChecker in the shot.

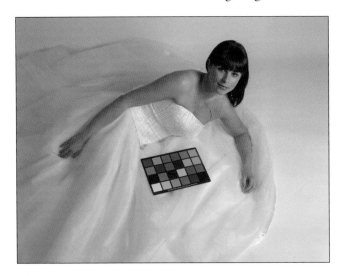

"As captured" photographs from an Olympus E1 camera.

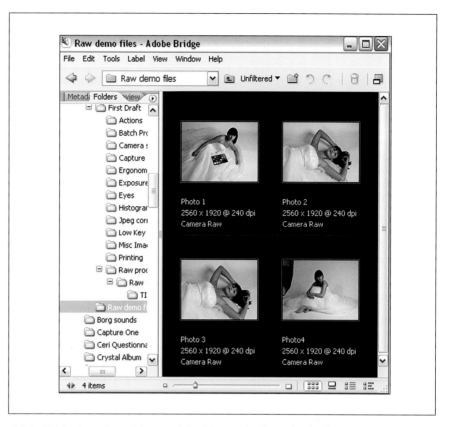

Adobe Bridge interface with our original images in the main viewing pane.

reflectors. They were shot at a trade show with the exposure fine-tuned by examining the histogram on the back of the camera and crowds of people wanting to know what was going on, so we were really up against it!

Not surprisingly, you can see that the images look a little lifeless and lack sparkle. Images always seem to look better on the camera's viewing screen, and the only way to see what they really look like is by viewing them on a calibrated monitor.

The first step in postproduction is to open the all the images using Adobe Bridge. This is the new interface that has replaced the old browser in the previous version of Photoshop and works across all of the Adobe Creative Suite programs. If you have set up Photoshop as described in chapter 6, Adobe Bridge should open up automatically and sit in the system tray at the bottom of the screen.

Hold down the Shift key and click the first and last thumbnail image to select all images. Right click over one of the images followed by another click on Open. This automatically opens up the Adobe Camera Raw converter, allowing us to make several key adjustments in order to provide us with our optimum image.

We are not going to consider all the various elements of the RAW file converter; we'll concentrate on the ones that are most important to a speedy workflow. Let's start by looking at the important tools in the Camera Raw screen shot on the next page.

> The first step in postproduction is to open the all the images using Adobe Bridge.

The Camera Raw Dialog Box

Green Ellipse. The auto correction tools (exposure, shadows, brightness, and contrast) are a new feature of the RAW file converter. Like all auto functions of Photoshop they go a long way to solving complex problems and give a good representation of the final image, but not always the one you want. For instance, if you intentionally take a silhouette, Photoshop will try to correct it.

We can turn off these correction tools by using the Ctrl/Cmd+U keys, but let's leave them on for now.

Red Ellipse. The eyedropper tool, shown here, is probably the most important tool when trying to achieve correct white balance and color accuracy.

Blue Ellipse. The RGB values are displayed on screen and, when used in conjunction with the other tools, tell us just how precise our corrections are.

Other windows indicate the color space Adobe RGB (this can be changed to sRGB if preferred, but refer to chapter 6 [color management]). The bit-depth field for the processed image is set to 8, and ready for output with minimal manipulation. Output resolution is set to 240dpi, which will determine the overall physical size of image, but this is generally a matter of preference. (240dpi is the native capture size of Olympus RAW files.)

This is where the real magic starts. If the reference image is not in the main window, click the thumbnail in the left-hand pane. The Auto function of the RAW converter (ringed in green) rarely gives you the desired effect, so select the white balance eyedropper (ringed in red), place it over one of the gray squares at the base of the ColorChecker (I suggest the third square from the right; this square represents 18% gray), and just click.

This will automatically shift all the colors in the image to neutral, removing color casts. You will also notice that the white balance field will shift from As Shot to Custom, and the sliders in the adjustment settings will reposition themselves to compensate for the color shift.

The auto correction tools are a new feature of the RAW file converter.

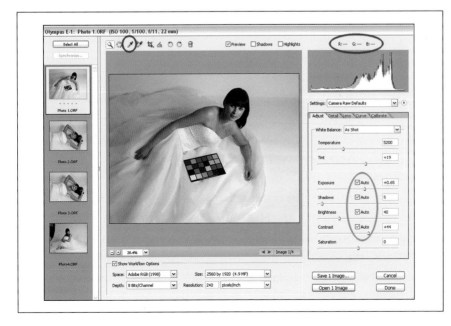

Adobe Camera Raw with the main features circled.

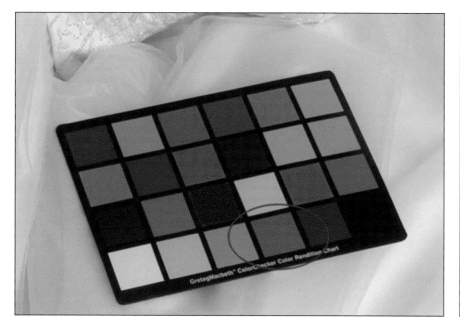

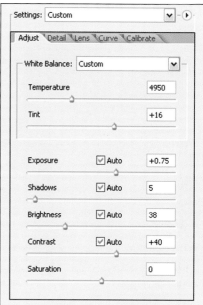

Above—The 18 percent gray square of the GretagMacbeth Color Rendition chart. **Top right**—The control box after clicking the 18 percent gray square with the white balance tool. **Bottom right**—The RGB field of the RAW converter dialog box after clicking on the 18 percent gray square with the white balance eyedropper. The fact that the values are all the same tells us that our image is neutral.

In chapter 4 we turned off the color, tone, and sharpening controls in the camera to give us greater control during postproduction. Having sorted out the color by using the white balance tool, we are now going to turn our attention to the exposure and tone of the image.

Look at the section of the RAW converter ringed in blue. We can see a representation of the RGB values of our selected image. When you let the white balance eyedropper hover over the 18 percent gray square we used to correct color, the values are R90, G90, B90. The fact that the values are all the same indicates that the image is neutral.

Neutral gray, no matter what shade, will have equal values of red, green, and blue (e.g., R125, G125, B125 or R30, G30, B30). The information provided with the ColorChecker indicates that the numeric value for this square in RGB terms should be R117, G117, B117. This, however, is averaged due to the values of RGB varying with color space between 107 to 127. What matters is that the image is neutral. Using the average value of 117, we now need to correct the exposure and tonality of the image using additional controls.

The control panel on the right of the RAW file converter includes an Exposure (compensation) slider. Highlight the 0.00 in the box to the right of the slider, and position the white balance eyedropper over the 18% gray square again, then use the up/down arrow keys on the keyboard to adjust the slider. Watch the RGB values at the top right of the screen, and stop when the values reach 117, 117, 117 (or as close as you can get them).

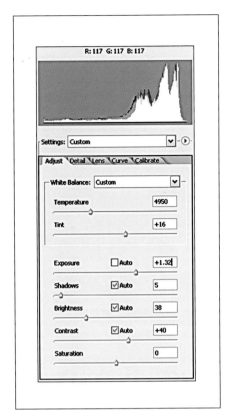

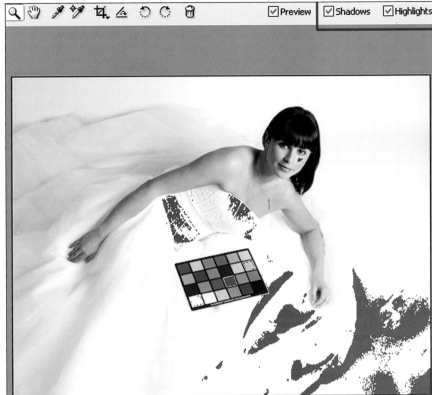

The check mark in the Auto box above the Exposure slider will disappear due to this manual adjustment, and the other control sliders will automatically adjust to compensate for the change. The image has now been adjusted for color tone and exposure, and we can see that the image was just over 1⅓ full stop of exposure from our original settings. Let's check that our adjustments can be printed within the capabilities of our inkjet or the lab's printers.

To the left of the RGB color value indicators in the RAW conversion palette, there are two check boxes, Highlights and Shadows, that can be selected to show colors that are out of gamut. When these are selected, the preview image in the main pane shows color patches in each of the areas that will have clipped color and will not print correctly.

The image above has been deliberately overcorrected to demonstrate the preview pane. If working in the sRGB color space, the corresponding areas, which are now beyond the tonal range of most printers, will be slightly different.

The following method can be used instead of checking the Shadows and Highlights indicators, to better show clipped detail in these areas.

Let's go back to our image in the RAW converter. Without making any further adjustments, hold down the Alt key and click on the Exposure slider at the same time. The image should change to a blank black screen. If the image had been overadjusted, you would see some color inclusions—or even worse, white. Color inclusions would indicate that one or more of the Red, Green, or Blue channels has been clipped. White would indicate that all three

*Left—Adjustment panel after exposure compensation of 1⅓ stops. **Right**—The Shadows and Highlights boxes are selected in the RAW conversion palette.*

channels have been clipped and the highlights have no detail in them. Our sample image shows some minor clipping in a small section at the edge of the dress. All we need to do is back off the Exposure slider until this clipping disappears; but in this instance, the affected area is not critical and will go unnoticed. We can use the same technique to check for clipping in the shadows by holding the Alt key and clicking the Shadows slider.

If none of the shadows have been clipped, we can add a little contrast to the image by moving the Shadows slider to the right while holding the Alt key until the color inclusions or black spots appear, then backing off a couple of points. The final corrected image can be compared with the original below.

Now that we have adjusted our reference image, it's going to take an age to correct the other images in the same way from our portrait session, right?

Once you have mastered this method of RAW file adjustment, it can be done in a matter of seconds, but we do not want to spend all our time adjusting the remaining images in the same way. Though we have only four images in our sample session, we could easily have fifty!

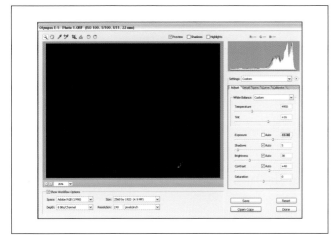

With Adobe Bridge still open, use the Select All button at the top left of the thumbnail column. All the remaining images have now been selected and the Synchronize button also becomes active. When clicked, the Synchronize dialog box appears, with all of the possible adjustments selected. When OK is selected, the changes made to the reference image are transferred to the remaining files without having to open them or work on them individually. The changes we have made are not permanent, and we could easily start from scratch again if needed.

With the adjustments made, we have a couple of options available. We can select a single image or multiple

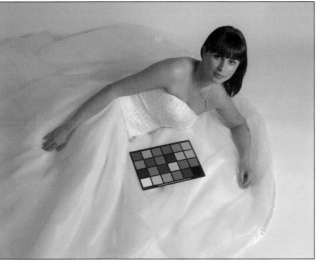 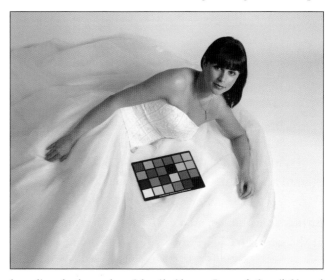

*Top—Hold down the Alt/Opt button and click the Exposure slider to show clipped colors or loss of detail. **Above**—Image before (left) and after correction (right).*

images and open them in Photoshop, ready to crop and make final artistic manipulation, or select Done, which closes the Camera Raw dialog box. This will be our preferred option in this instance.

The adjustments we have made are saved in .xmp sidecar files (i.e., the metadata is stored in a separate file, rather than with the main file), which are cached in the same location as the original RAW file. This means that when Adobe Bridge opens the files for viewing, it calls for the adjustment information in the sidecar file and represents the adjusted image in the viewer without having to open up the file and apply the adjustments to the main image.

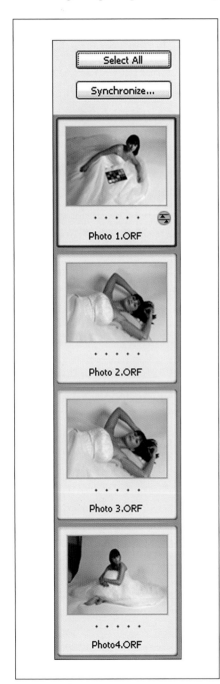

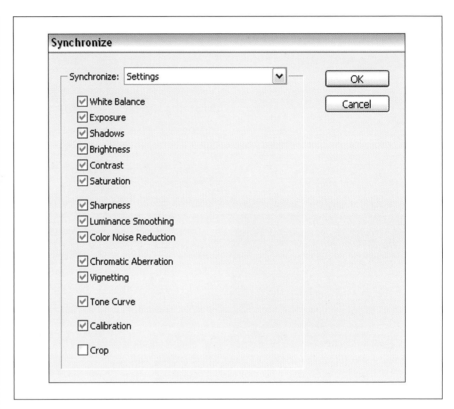

Left—Pick Select All to choose all the remaining files in Adobe Bridge. *Right*—The Synchronize feature corrects all selected images to match the original adjusted image.

BATCH CONVERSION

One of the major changes to Photoshop CS2 over the previous version of Photoshop is the inclusion of an image processing program for RAW files. This was previously only available as a special plug-in.

So far we have only processed the image files to their "optimum exposure." They must now be converted to a working file format so that we may apply our remaining cropping and compositional adjustments. This is done by applying a script file, but just like everything in Photoshop it can be accomplished in one of several ways.

Drop-Down Menu

From the drop-down menu, select File> Scripts>Image Processor and a new dialog window appears.

Section 1 of the dialog box asks you to select the files required for processing, which is done by browsing for the required files. Do not select Open First Image to Apply Settings, as we have already done this in Adobe Bridge.

Section 2 asks where you would like to save the images. We could select another folder, but it makes sense to leave them in the same folder. The processor creates a separate folder automatically based on the type of file we convert the RAW images to.

Section 3 lets us determine the file type (JPEG, PSD, or TIFF). We could choose all

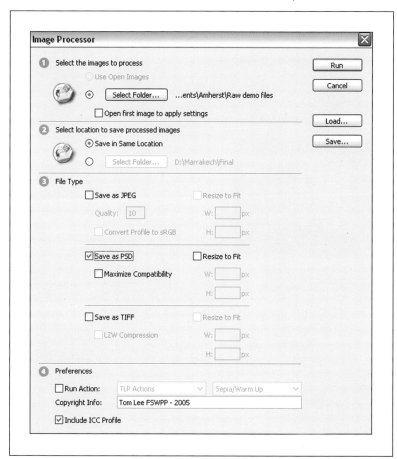

The Image Processor dialog box.

three if we so desired! We have chosen to work in PSD mode but do not want to resize at this stage.

Section 4 allows us to run an action at the same time. Because we have adjusted our images for optimum conditions, we could run a sharpening action to put some crispness back into the file, or a sepia toning action to create a monochrome set, but in this exercise let's just add some copyright information as an embedded tag to the file. When opened, a copyright symbol will appear in the top left of the title bar. There are no excuses for anyone stealing your images! Also check the ICC profile box. Remember when we discussed color profiles in chapter 6, we only assign the color profile during conversion of the RAW image. If the image has been captured in the sRGB color space, then the files will be assigned that color space, but when the images are opened for the first time in Photoshop, if we have set the program up as described in chapter 6, we should get a profile mismatch warning because the working profile of Photoshop has been set to Adobe RGB (1998).

Just click the Run button and watch it all happen. However, if you choose to process fifty images, you may want to grab a bite to eat! It does take some time, but it will free you up to do something more productive elsewhere in the studio.

If the image has been captured in the sRGB color space, then the files will be assigned that color space.

Adobe Bridge

The process of converting your images using the Image Processor dialog box is exactly the same when using Adobe Bridge; however, you can be more selective with the images chosen to be processed or select the entire folder on view.

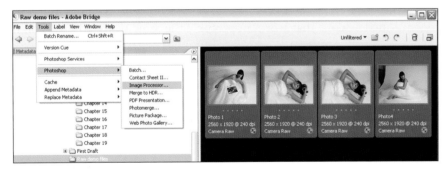

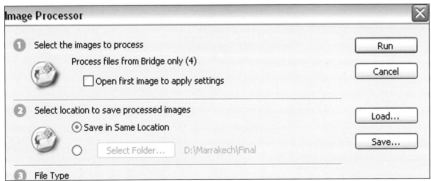

Batch processing selected files from Adobe Bridge.

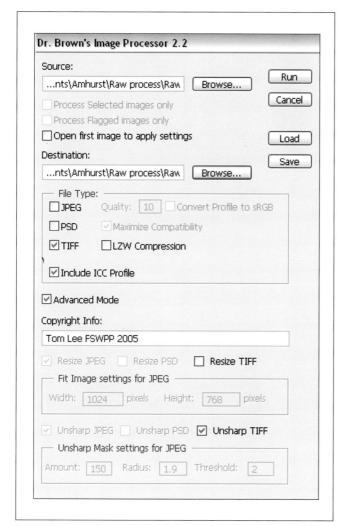

The Adobe Camera Raw plug-in for Adobe Photoshop.

Select Tools>Photoshop>Image Processor from the Adobe Bridge drop-down menus, and the dialog will assume that you want to process the entire folder. If we want to be more selective, we can Ctrl/Cmd+click individual images in the folder and then choose Tools>Photoshop>Image Processor and an additional option will read Process Selected Images Only. Clicking Run will process only the selected images.

When the process has been completed, check the folder with your RAW images and you will find a second folder labeled PSD. This folder contains all the images you have just processed, but the files are now in a PSD format ready for final creative adjustment.

Processing RAW files in Photoshop CS (as opposed to CS2) is just as easy; however, you will need a plug-in downloaded from the Internet. Dr. Russell Brown has a fascinating website (www.russellbrown.com) that has all things digital to do with Photoshop (he was instrumental in developing the Image Processor in the current version of Photoshop and is Adobe's creative director). Brown's site offers several scripts, which can be loaded into Photoshop for precisely this purpose, and they're free!

The one that we are interested in is the Camera Raw processor. If you follow the instructions (after watching the hilarious video that accompanies it), you will have downloaded a script that works in precisely the same way as the version in Photoshop CS2, although the interface is slightly different.

When you have successfully loaded the script file into Photoshop, go to File>Scripts>Dr. Brown's Image Processor, and the palette will open as in the photo below. If it isn't fully expanded, check the Advanced Mode check box.

Fill in the required fields and click the Run button. After a while you will have successfully converted all your RAW files, and will be ready to apply the full weight of your creativity.

WORKFLOW

In the preceding chapters, we've reviewed the intricacies of RAW format and conversion, but now let's consider the actual business of undertaking a wedding shoot and the various steps and precautions taken to achieve a successful result.

The following workflow is broad based and is loosely constructed around my own working practices.

Photograph

It is unlikely that you will want to take photographs of the ColorChecker in every location, particularly as photojournalistic wedding photography is in vogue. We simply don't have the time to do this, and the bridal couple would get fed up quickly. The whole point of this style of coverage is "no fuss." Therefore, we will discuss a workaround later in this chapter.

After selecting the camera settings outlined in chapter 4, making only the minimal adjustments necessary (flash EV compensation and ISO rating) will allow you to concentrate on your composition and devote more time to your subjects than your equipment. There is no substitute for practice—trying these techniques on live weddings without some experimentation and the utmost confidence in your equipment is a recipe for disaster. As explained earlier in this book, identical camera models can have minor differences that record images quite differently, and some manipulation after capture is inevitable. The whole point of adopting a middle ground approach is so that no matter what camera, system, or lighting techniques are used, the images captured on your digital media will be almost at their optimum, minimizing the need for any postproduction work.

Today's high-end professional cameras all have excellent light metering built in, and the metering is accurate enough for me not to worry about taking separate handheld readings, which demands additional time and effort. Center-weighted metering will generally give excellent results for the major-

Identical camera models can have minor differences that record images quite differently.

Carry pouch (left) and storage card (right).

ity of our photography, as our subjects will usually be in this region of the image when focusing (even when recomposing). Spot metering is a little over the top but does become useful if detail is required when photographing backlit scenes. Full-frame evaluative metering tends to overcompensate for highlights in the scene and will generally underexpose the image too far.

The size of your digital storage media is important. Using small storage cards will mean changing them frequently—and this becomes tedious. Durability problems with digital media can cause anxiety when error messages appear, so using large-capacity cards is like putting all your eggs in one basket! A problem with image 2 on the card may prevent the download of all the remaining files, so be cautious. If you haven't had a problem with your digital media yet, you will! Shooting in uncompressed RAW format on the Nikon D2x with a 1GB card will allow approximately 40 images to be stored. This keeps me in a comfort zone of not too many and not too few.

The cost of media is coming down daily, so there is little point in *not* having lots of memory cards. Label all your media with a reference number or letter to identify them and store them in a carry pouch. To identify used cards, turn them back to front!

The cost of media is coming down daily, so there is little point in not having lots of memory cards.

Backup

As soon as possible, download the images to the hard drive of your computer. Prior to making a backup copy, you may want to rename your files. Using the default file naming of the camera is not very imaginative and can be confusing. I suggest using the media card reference followed by an image number: 1-001 to 1-040, 2-001 to 2-040, 3-001, etc. This not only identifies the media card the image came from but also the sequence number, which is handy if you encounter problems with the downloading process. This is usually done in Adobe Bridge via Tools>Batch Rename.

Once you select Tools>Batch Rename, a separate dialog box appears that allows you to make several selections and add additional fields to the file

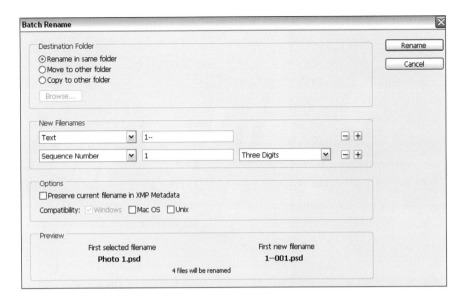

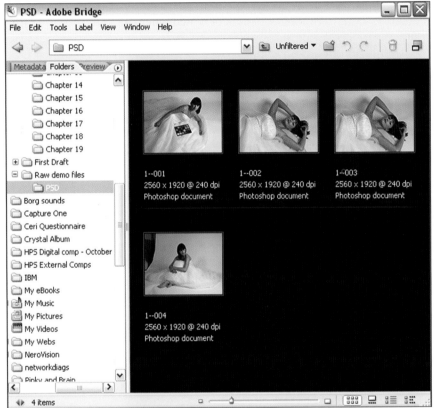

name. In the bottom pane of the dialog box, you'll see the current file name and the proposed file name. Before committing the changes, you can edit the details if it isn't quite as you intended. To commit the changes to all the files, ensure that none of the images are highlighted and click the Rename button. If you have highlighted individual files in the preview pane, the renaming will only apply to the selected files.

We can now make our first backup copy. This is our "just in case" file, which can be accessed quickly should anything happen to the main hard drive working files. When backing up, using a separate removable hard drive

that can be disconnected from the studio network to help prevent corruption is advisable. We now have three copies of our images including those on the media cards that have yet to be erased. Make a complete DVD backup for archival purposes. This DVD should be stored and only accessed if one of the two hard drive copies is corrupted in order to restore the working files. This belt-and-braces approach to backing up your work may seem excessive, but when your livelihood depends on getting the job out and avoiding heavy litigation from your client, you'll be glad you did it.

Just before you delete those valuable files on the media cards, it's worth checking that your backups all match what you have on the main hard drive. There are many file comparators on the market that can be purchased over the web for very little money and compare destination and source files for data inaccuracies, flagging dodgy files before they cause you a problem.

Once the files have been backed up and checked for accuracy, it's pretty safe to delete the files from the digital media. There have been reports of memory cards occasionally being corrupted when deleting files from the media while attached to the computer. So to be safe, reformat the cards in the camera.

Once the files have been backed up and checked for accuracy, it's pretty safe to delete the files.

Process

We can now get on with the business of formatting our RAW files. We start by processing the files as discussed in chapter 7, but with one important difference. It's unlikely that we will have used a ColorChecker; however, using the White Balance tool and clicking on an area of the image that should be a neutral shade of gray (white wedding dress, jacket, tablecloth, shirt, flowers, etc.) will neutralize any color cast in the image.

Selecting a light area will make the image appear warmer in tone than choosing a dark jacket, which will tend toward a cooler blue or green tone.

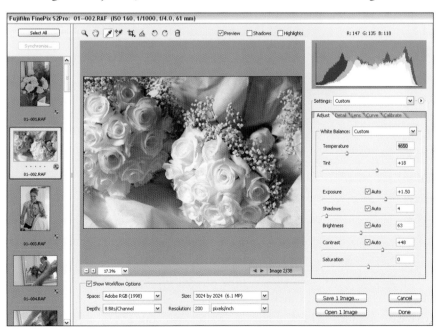

Color corrected image using white balance eyedropper on white tissue behind flowers.

The color temperature will not be able to be made absolute, however; as color preference in the image is usually subjective, moving the Temperature slider until the image looks right means it probably is and will produce a pleasing printed result. In our sample screen shot, the exposure has been adjusted to +1.5 stops. This is due to the predominantly light image fooling the internal exposure meter of the camera and underexposing the image; however, with the use of RAW file conversion, the image has been optimized without any significant degradation.

The process of balancing all the remaining images is done exactly as described in chapter 7, including the use of the Synchronize button for adjusting multiple images with similar tonal values and lighting. Once balanced and processed, we can convert the images using the Image Processor into 8-bit PSD files for creative manipulation.

At this point, depending on your studio operation, you may wish to create a copy file of your converted images. This is useful if you want to save master copies for album design and separate fully manipulated images for uploading to the web. In either case, the images are not resized.

Presentation

Photographers have many options when it comes to presenting their images to the client, including transproofing, individual proof photographs, and *Previewing by digital projection.*

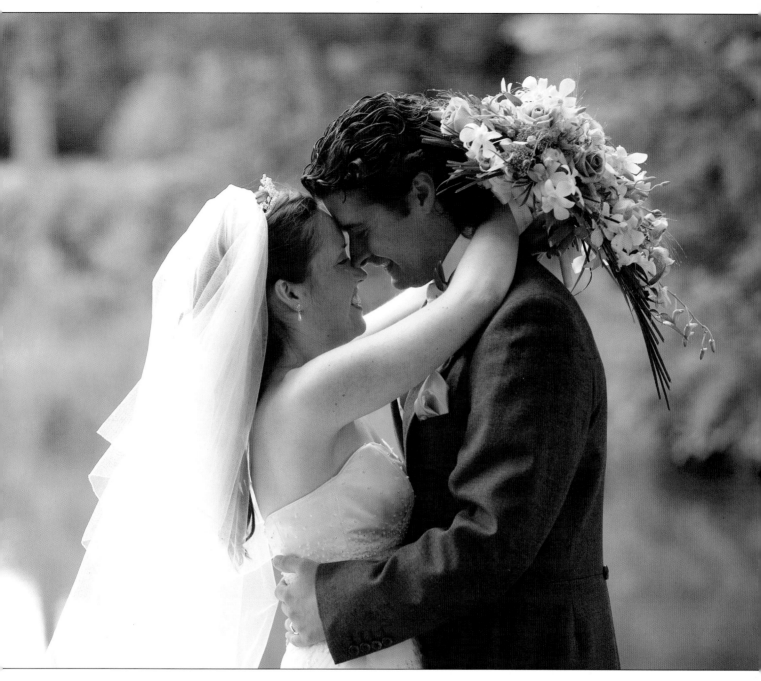

An "as captured" moment, shot with strong side light and fill flash.

video. In today's technological age, the method that gets the wow factor working for you is digital projection onto a large viewing screen. As the adage "bigger is better" suggests, showing larger images tends to increase sales.

Another conundrum is what to show your client. Do you show them individual images or a completed album? Showing a completed album may reduce your upselling of individual prints but will shorten design times on the album because you are not waiting for the client to make up their minds.

Whichever method you choose is bound to pay dividends, but projecting images usually demands smaller files. We can run an automated batch process in Photoshop to do this prior to loading the images into our slide show program.

When the slide show has been made, burn it to a CD or DVD and offer it to the client as an add-on. It's important that this is not done until payment has been received for other goods due to the ease of copying electronic media.

When the client is happy with your artwork and album design, your only remaining task is to produce their album. This is detailed in chapter 15.

How Long Does it Take?

Though today's technology is good, things will undoubtedly get better and faster. I have attempted to distill some working times to the above workflow based on current computing equipment, but as specific hardware will differ with individual specification, and photographers' expertise with Photoshop is unpredictable, the times shown are variable.

Burn the slide show to a CD or DVD.

Workflow Time Table	
TASK	TIME
1. Take photos at the wedding.	all day
2. Download images from digital media.	1–5 minutes
3. Rename all files in Adobe Bridge before converting (1-001 to 1-038, 2-001 to 2-038, etc.).	2 minutes
4. Back up RAW files to second hard drive and DVD.	30 minutes
5. Check the DVD and backup drive using comparator software to ensure files were recorded.	5 minutes
6. "Process" files in Adobe Camera Raw.	100 images/hour
7. Convert the files in Image Processor.	leave it running
8. Crop files, make artistic adjustments (monotone, sepia tone, etc.) and sort into order by sequence (using Adobe Bridge).	100 images/hour
9. Upload high-quality files to online ordering server.	100 images/hour (288KB)
10. Batch convert to make presentation slides (see chapter 8).	30 minutes
11. Make manual and auto presentation slide shows (see chapter 14).	10 minutes
12. Burn slide show CD/DVD.	10 minutes/30 minutes
13. Sell to clients.	as long as you like

WORKSTATION ERGONOMICS

Before we delve into the fine detail of image adjustment and creative workflow, it's worth considering how we are going to work comfortably and efficiently at the computer (ergonomics).

The photos below show a typical two-screen layout with keyboard and graphics tablet. The work area is uncluttered and not a mouse in sight.

Monitors

In days gone by, the use of liquid crystal display (LCD) monitors for high-quality graphics work was unheard of, mainly because of the difficulty in obtaining good color accuracy. Cathode ray tube (CRT) screens were the order of the day due to high color accuracy, good contrast ratios, and were also about half the price of the equivalent LCD monitor.

Things seem to have taken a complete turnaround in the last few years. Manufacturers are dropping out of the CRT market due to a global decision

The workstation and two-screen setup.

to gradually phase out production. It seems that an average CRT monitor contains approximately 7 pounds of lead shielding, which is proving to be a headache to dispose of. Although there are a number of manufacturers still producing this type of monitor, their numbers are ever decreasing.

The production and sale of LCD monitors, on the other hand, has grown by leaps and bounds. Recent tests have shown that some LCD screens outperform their CRT counterparts. They also have the added benefit of running at higher brightness levels, meaning that ambient room lighting can be higher than for CRT screens without affecting performance and therefore making the working environment much more comfortable.

Although the images show an LCD and CRT monitor, the basic layout is the same no matter what type of screen you are using. Photoshop CS2 allows the use of floating palettes, which means that the individual palettes, images, and work areas can float over both screens increasing the area of on-screen workspace. The left-hand screen is used for keeping the most-used palettes open and accessible without having to move them around or go hunting for them in menus or the docking bay.

The right-hand screen is used to display the main working image without being cluttered with palettes and dialog boxes. Both screens are raised to eye level, reducing the possibility of neck strain, and the screens are large enough (20-inch viewable) to have them positioned away from the face, reducing eyestrain.

The left-hand screen is used for keeping the most-used palettes open and accessible.

Input

When inputting information or working on image manipulation, it's important that you are comfortable; after all, you could be at your workstation for hours. Your seat should be well padded and adjustable for both height and tilt. It should also be raised so that your eyes are in line with your monitors and the angle of your upper and lower arms are at 90 degrees.

A Wacom graphics tablet and setup screen.

The specific orientation of your keyboard and graphics tablet depends on whether you are right or left handed; however, one hand is used to cover the keyboard shortcuts and action keys while the other is used to operate the graphics tablet. Never try using a mouse to do any fine retouching work or delicate selections—it's like trying to paint with a bar of soap!

Though there are many graphics tablets available, the most commonly used is the Wacom series. The tablet should be large enough to allow good hand movement over both screens. About a 6x8-inch area should be big enough, but do not be tempted to use something smaller. Conversely, too large a tablet can get in the way and takes up a lot of space. When using two screens, the Wacom tablet usually auto detects the configuration and recalibrates the plotting area of the tablet into two separate halves; one side for the left monitor and one side for the right.

The tablet should be large enough to allow good hand movement over both screens.

Worktop

The worktop is usually kept clear in case of visitors, but in busy periods (for instance, when writing this book) it allows for a layout space, reference area, and even room for telephones and a laptop!

The desk area is "U" shaped so that a simple spin around will give easy access to reference material or even just get you away from looking at images for a while.

Relax

Remember that taking a short break at regular intervals not only allows relief for your eyes but relaxes the whole body, allowing you to work for longer periods.

Have you ever wondered why the last image you worked on never quite looks as good as the first? It's all to do with relaxing the body and the eyes in particular. When you get tired, blood sugar levels rise, causing the cone receptors in your eyes to change shape—and this will alter your perception of color. Some major laboratories insist on operators taking regular breaks (sometimes every half hour) followed by a brief look at a black & white image prior to returning to the screen. This seems to act as a reset switch in the brain, allowing you to see colors consistently.

COLOR CORRECTION

In this chapter, we'll examine some files and apply basic color corrections to them. At this stage we are going to get deeper into our processing workflow, and we'll look at some quick fixes as well as more elaborate methods of adjusting images.

First, open Adobe Bridge and move it to the left-hand screen. Select an image to open and click in the center of the image with your graphics stylus. Drag the image into the desktop area of Photoshop; this will automatically open the Adobe Camera Raw adjustment palette if the image was captured in the RAW format.

12-Bit RAW

The photograph shown in the screen shot below was captured in RAW mode with center-weighted metering and auto white balance. The color, tone, and sharpness were turned off. A small amount of fill flash was used to remove heavy shadows from the face, and the camera was left to capture the image as best it could. This was just one of a series of images, but we will examine this particular image on its own merits.

The automatic adjustment settings are all checked and have therefore tried to correct the image. To see the image as it was captured, press Ctrl/Cmd+U to de-select the auto settings. We can see that although we have used a little flash, the metering has been fooled by the large amount of "light" in the overall scene and the image has been slightly underexposed. Look at the histogram on the right-hand side and you will note that it conforms to our expectation of a good capture (chapter 3). This is where RAW processing comes into its own (review chapters 7 and 9).

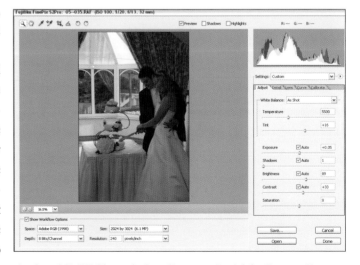

A selected RAW file ready for adjustment in Adobe Camera Raw.

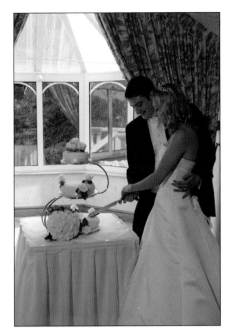

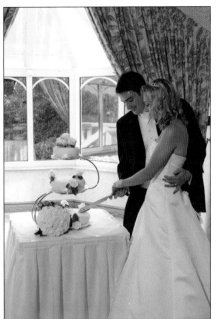

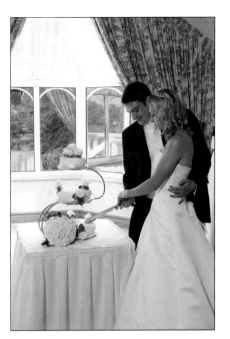

Top row—(Left) Image corrected for neutrality with the White Balance tool clicked on the lighter part of the bride's dress. (Center) Image corrected for exposure and shadow detail. (Right) Image balanced for color temperature. Bottom row—(Left) Original histogram showing most color information in the darker tones of the image. (Right) Postproduction histogram showing increased color information in the lighter tones of the image.

Now turn the auto settings back on (Ctrl/Cmd+U) and select the Auto White Balance tool. Clicking in the lighter area of the bride's white dress immediately removes any color cast but requires some adjustment of the exposure. All that remains is to adjust the Temperature slider to produce an aesthetically pleasing color, and a slight tweak of the Exposure and Shadow sliders to complete the transformation. Remember that RAW images have been captured in 12 or 14 bit and are only converted to 8 bit when opened.

The original and postproduction histograms are shown below to compare the effect of removing underexposure and applying corrections to produce the high-key final image.

8-Bit JPEG Precise Approach

Making color adjustments to 8-bit JPEG captured images is trickier but still possible. The only difference (and it's a big one) is that much of the information present in the 12-bit RAW file is absent so we are already handicapped. Open the same image in the RAW converter and press Ctrl/Cmd+U to remove the auto corrections. Ensure that As Shot is selected for the white balance option, and process the file without making any adjustments by clicking the Open button. The resulting file is processed as if it was shot in JPEG

mode and converted in camera. It's obvious from the outset that the fill flash has not fired, rendering the image grossly underexposed.

We need to select the Eyedropper tool for the tools palette and make sure that it is set to 5 by 5 Average in the Options bar. Next, create an adjustment layer by clicking Layer>New Adjustment Layer>Threshold. When the dialog box appears, just click OK.

We can use the slider in the Threshold histogram to find our brightest and darkest point of the image. Move the slider to the left of the histogram and the black & white image will almost disappear, aside from a few areas of black. We need to select an area of shadow that we require detail in (this may not be the darkest point of the image). Hold the Shift key and place the cursor over the black area and click.

This selects our first color sampled area and adds the RGB information to the Info palette. Next, we move the slider over to the right of our Threshold histogram to check out the brightest areas of the image. Hold down the Shift key and click in the area you want to sample.

After adding our sample points, we can cancel the Threshold histogram. When your image reappears, it will have two targets left in the areas where we sampled color. With this accomplished, we can start making our color adjustments.

First, create a new adjustment layer via Layer>New Adjustment Layer> Levels. When the Levels dialog box appears, we will neutralize the color cast by using the individual Red/Green/Blue channels and moving the black point and white point sliders until all the channels give the same value for highlight and shadows.

Next, look at the Info palette (below right) and view the information for color sample #1. This is our shadow area and gives values of R24, G18, B14.

Selecting the 5 by 5 Average option for the Eyedropper tool in Photoshop.

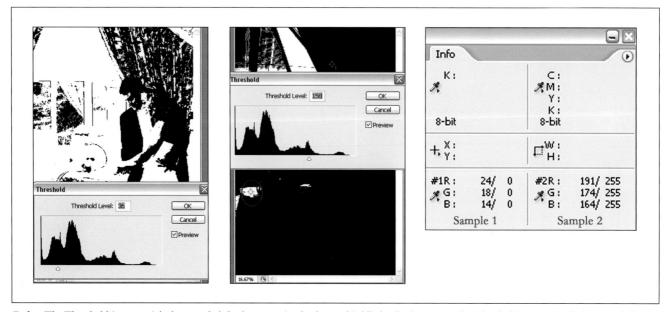

Left—*The Threshold image with the sampled shadow area in the drapes highlighted.* **Center**—*The Threshold image with the sampled highlight area in the tablecloth selected.* **Right**—*This adds a second color-sampled area to the Info palette.*

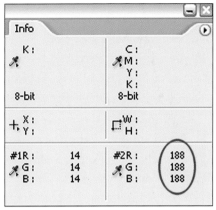

Red channel adjustment (above) and Green channel adjustment (center).

The Info palette after adjustment of sample areas 1 and 2.

Because we are going to balance the shadow areas first, we need to look for the lowest value and find which channel it applies to. In this case the lowest value is 14 in the Blue channel. In order to balance the color we need to make the other two channels match this figure.

Select the Red channel first by using the drop-down menu in the Levels dialog box and move the Shadow slider of the Levels palette until the numbers in the Info palette match those in the Blue channel. It's important to look at the figures in the Info palette and not the ones in the Levels palette. Repeat the process for the Green channel, moving the slider until the numbers in all three channels match. We have now adjusted the shadow areas in the image to neutral. It's important to note that the shadows will not be black, but merely adjusted for neutrality.

The process of balancing the highlight areas is similar, but this time we will be looking at sample number 2 in the Info palette. This time, we need to adjust our balance for the highest value in the group, which is 188 in the Red channel. In the Channel field of the Levels palette, select Blue and move the highlight slider to the left until the numbers match those in the Red channel. Repeat the process for the Green channel.

Occasionally after adjusting the highlights you may notice that the numbers in the shadow color sampler have shifted. As long as they don't move more than a couple of points, there is no need to revisit the shadow areas and readjust the colors.

Once the highlight and shadow areas have been adjusted we can turn our attention to the midtones. Let's make a new adjustment layer via Layer>New Adjustment Layer>Curves. We can add a third sample point by holding the Shift key and clicking in the midtones (usually the shadow side of the dress). The procedure for neutralizing the midtones is similar to that of the Levels adjustment, but this time we need to select the middle value, which in this case is 83 in the Green channel.

To prevent Photoshop from making further changes to the carefully adjusted highlight and shadow values, we can lock the curve in place by adding fixed points along its length. Select the Red channel from the drop-down menu in the Curves dialog box and click on the line close to the highlight and shadow ends. This will fix the values at each of these points, allowing us to make changes in the midtones.

Let's add another point near the middle of the line and type in the Input and Output values from the Info palette. The input values for sample number 3 are on the left of the Info palette, and the output values are on the right. The midtone value (Green channel) is 83 (input matches output). In order to make all three channels neutral, we need to select the Red channel and type into the Curves palette an input value of 82 and an output value of the midtone 83 (top right). Similarly, the Blue channel input value of 87 needs to match the midtone output value of 83 (center right).

The image has been properly color corrected, and all that remains is to adjust the exposure, add contrast, and saturate the colors slightly to give the image a little more impact.

Open the Levels palette by pressing Ctrl/Cmd+L and drag the highlight slider (bottom right) and contrast slider (center) to the left to increase contrast and brightness levels, then open the Color Balance dialog (Ctrl/Cmd+B) and apply +13 Red and −13 Yellow to give the image a pleasing warm tone. The before-and-after images appear on the facing page.

Quick Fix 1

Although JPEG images can be converted as described above, the process of achieving high-quality results quickly is not easy. Photoshop has a new adjustment palette that makes color correction to JPEG images less traumatic. Simply select Image>Adjustments>Exposure to access the exposure adjustment engine.

Once the dialog is open, you'll see three sliders: Exposure adjusts the highlights with minimal effect on the extreme shadows, Offset darkens the shadows and midtones with little effect on the highlights, and Gamma is used for general contrast adjustment.

There are also three eyedroppers available for your adjustments: The black eyedropper sets the offset, shifting the pixel you select to 0. The white eye-

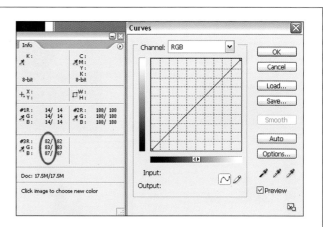

The RGB values of sample point number 3.

Red channel input and Green channel (midtone) output.

Blue channel input and Green channel (midtone) output.

dropper sets exposure, shifting the selected point to white. The midtone eye-dropper sets the exposure of the selected point to middle gray regardless of its color. It can have a disastrous effect on the image because the eyedroppers work on the luminance values of the image rather than the color content. If at all possible, don't use them—use the individual sliders. Be cautious when using the eyedropper tools, as they don't work in the same way as other eyedroppers within Photoshop. They adjust the luminance values rather than color.

Though using this approach is generally quicker, it's not as accurate and tends to change the color values globally rather than using a definitive approach within individual color channels.

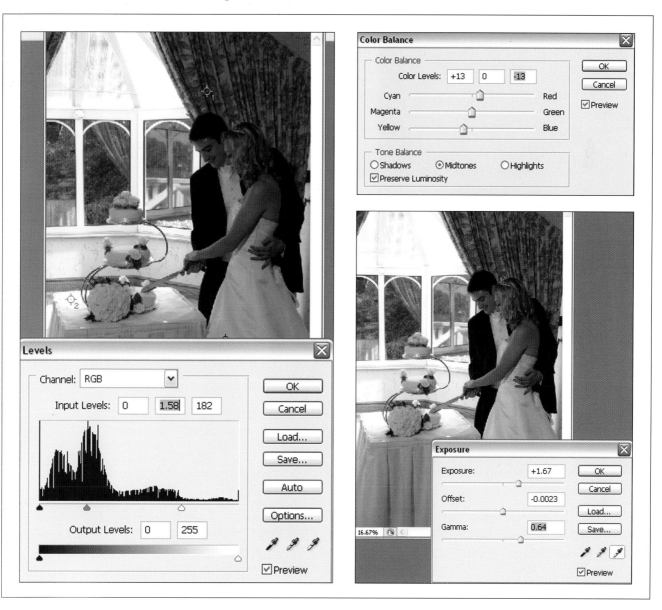

Left—Adjusting for contrast and brightness. **Top right**—*Adjusting for color.* **Bottom right**—*Photoshop Exposure adjustment feature.*

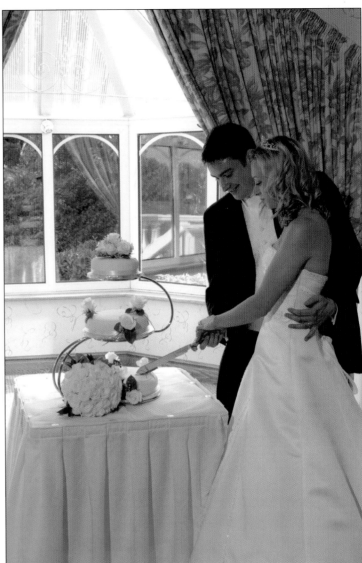

Original image (left) and adjusted image (right).

Quick Fix 2

The following method can be used when the image has a pleasing overall look but may need slight adjustment in the color balance to remove a general cast.

First, open your image, then open the Color Balance dialog box. The changes we are about to make are global, meaning that they affect the entire image, but this is a simple technique that can be applied quickly. Select the Eyedropper tool from the tools palette, and ensure that your selection area is set at 5 by 5 Average in the Options bar. Hover the Eyedropper over an area that should be neutral gray and observe the RGB values in the Info palette. Remember that for colors to be neutral, all values need to have the same number. In our example the Red, Green, and Blue channels are about 5 points adrift of each other.

The major changes will occur in the midtones. With your cursor in the third (yellow/blue) Color Levels field of the Color Balance dialog box and the Midtones button selected, move the Eyedropper back over the sample

area but do not click. Use the up/down arrow keys on the keyboard to adjust the slider until the blue value in the Info palette is equal to or at least within one or two points of the middle value. Repeat this for the Red channel, and keep adjusting the values until they average out. If you choose a shadow area of a wedding dress to sample, then make your adjustments in the highlight end of the tonal range rather than the midtones.

Any lack of contrast can be adjusted by making corrections in the Levels palette. Move the white and black sliders toward the ends of the histogram to make highlight and shadow adjustments, and move the center slider to adjust the midtones.

Left—Original image with overall blue color cast. Bottom left—The selection area shows a midtone value of 39 in the Green channel. Bottom right—Final adjustments in the Color Balance palette, showing the neutral balance of the jacket.

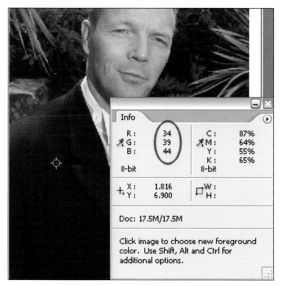

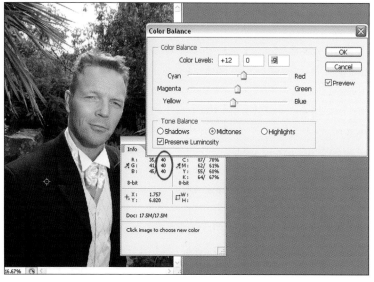

ACTIONS

In previous chapters, we identified the optimum camera settings for ensuring the best-possible images. We also looked at the pros and cons of JPEG and RAW file formats and mastered the art of RAW file conversion. We also learned how to batch process a large number of images in this format.

Regardless of the capture mode we choose, some images will require additional creative input prior to printing. Our goal in this is to achieve the final image we desire as quickly as possible without compromising the quality of the photo. This is where actions come into play.

What Are Actions?

Actions are a series of commands that can be recorded in Photoshop and played back using a key press or button in the Actions palette. Any number of commands can be recorded and saved in sets for easy access and recovery. Actions can be simple one- or two-part commands linked together, or complicated strings of Actions with controls that let you include variable inputs or user interactions.

Including Actions in our workflow provides us with time savings due to the repetitive tasks being undertaken in a fraction of the time it takes to do it manually. More importantly, these Actions are repeatable, and maintain consistency throughout the creative process.

Action Basics

To create a more efficient workflow, you can set up an action to handle your repetitive, time-consuming tasks. On this page, you'll find a list of the actions we've created for use in our workflow; a detailed, how-to discussion on how to create each is provided later in this chapter. (Note: Photoshop offers default actions, but you'll want to create custom actions that suit your needs. To save time, you can assign function ["F"] keys so you can play a given action at the click of a button.)

Time-Saving Actions
• convert to black & white
• add a sepia tint
• apply a soft focus
• sharpening 1
• sharpening 2
• pillow emboss
• shadows filter
• saturate
• stroke/drop shadow
• rotate left
• rotate right

Conversion to Black & White

There are several ways that you can convert an image to black & white.

Preferred Version. By using the Lab conversion mode, we can create a black & white image with brighter highlights, good contrast, and detail in the shadows. We'll create an action so that we may quickly apply our conversion technique with the push of a button.

1. First, ensure that the Actions palette is visible (if not, go to Window> Actions).
2. Click the tiny arrow button at the upper-right corner of the palette. When the fly-out menu appears, choose New Set and name the set as you like. We've named this one Adjustment Set.
3. Click the tiny arrow button to access the fly-out menu once more. This time, click New Action. Name the action Mono, and make sure that the set name you assigned in step 2 appears in the Set field in this dialog box. Next, assign the action to the F2 function key. Simply ignore the Color option at this point. Click the Record button in the top-right corner of the dialog box. (Note: There is no need to rush once you start the recording process. Take your time to make sure that you get the process right.)
4. Next, go to Image>Mode>Lab Color. This will not result in any noticeable change in the image.

Step 2 from our Mono action.

Step 3 from our Mono action.

5. Open the Channels palette (Window>Channels). Click on the channel labeled Lightness. Your image will be converted to black & white.

6. Next, we will need to go to Image>Mode>Grayscale. A window will appear that asks, Discard other layers? Click OK.

7. Now go to Image>Mode>RGB to prepare the image for printing. (Note that if we did this prior to discarding the color channels in step 7, we would have reverted to a color image.) The image looks good but could be improved by increasing the contrast, so we'll continue.

8. Next, go to Window>Layers. Click on the background layer and drag it onto the Create a New Layer icon at the bottom of the palette to create a background layer copy.

9. At the top of the palette, change the blending mode to Soft Light and set the layer opacity to about 35 percent.

*Top row—(Left) The Channels palette showing Lab mode (step 5). (Right) Creating a duplicate layer (step 8). **Bottom row**—(Left) Creating a bit more life in the image (step 9). (Right) The Actions palette showing all the commands used.*

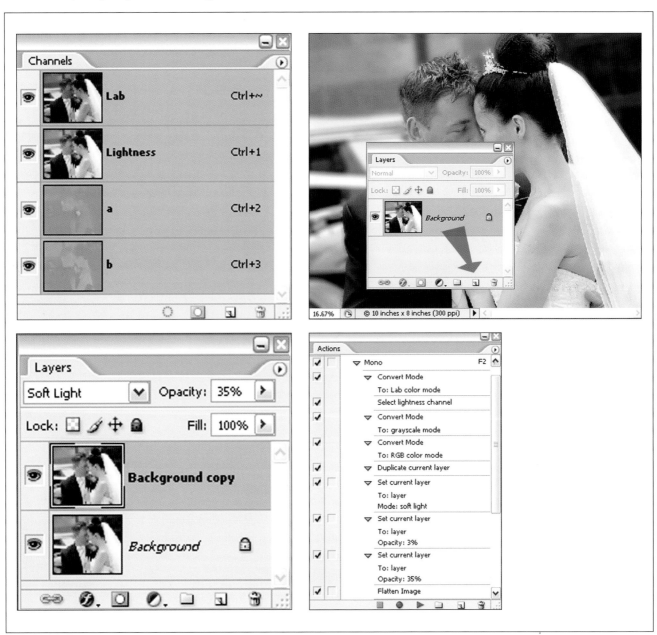

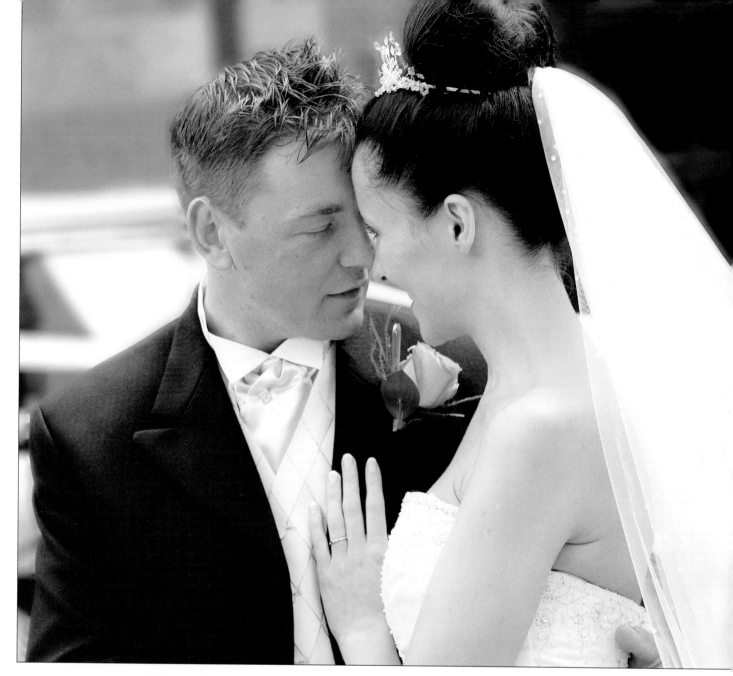

10. Go to Layer>Flatten Image.
11. Finally, click Stop.

Top—Optimized black & white image created using our Mono action. **Above**—*The Original color shows us where we started in our conversion process.*

You have now created your first action. Note that each stage of the process has been saved in the Actions palette, and that the entire sequence can now be played to duplicate the effect on another image (or group of images).

The image made using the Lab Color conversion has cleaner blacks and a lot more "pep" than simply desaturating the image (see "Muddy Version" on page 74). (If you find that the image requires lightening or darkening, simply open the Levels palette [Ctrl/Cmd+L] and move the center slider right or left to adjust the midtones in the image.)

In our discovery of Photoshop Actions, we will discuss several alternative techniques for applying a similar image effect; however, only the preferred technique needs to be added to our Actions set. Adding additional versions

of the process only provides us with "options" that may only serve to confuse and provide marginal benefits to the finished image. You can of course add as many variants of the technique as you need.

Muddy Version. We could easily go to Image>Adjustments>Desaturate to quickly convert our image (or use the keyboard shortcut Ctrl/Cmd+ Shift+U). This method, however, creates a slightly muddy black & white

Compare the muddy version (top) to the preferred version (bottom).

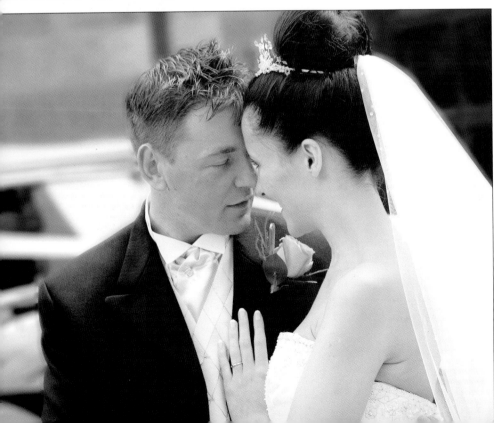

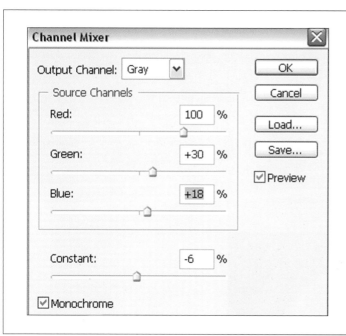

Left—Channel Mixer settings for a high-contrast mono image. Above—The Layers palette with the Channel Mixer adjustment layer.

Button Mode

I've recommended that you assign function keys for all of your frequently used actions. However, if this method proves cumbersome, you can simply access the Actions palette in standard mode and click Play. Better still, you can click on the arrow in the top-right corner of the Actions palette and scroll up, then select the Button Mode. Actions are applied by a single click of the required action button. (Note: When the Button Mode is active, you will not be able to record a new action. Deselect the option and proceed as in step 1 [previous page] to record a new action.)

image with no sparkle. It does, however, have its uses—this approach does not destroy the fine detail between high-contrast areas in the image.

This version of the Mono filter is fairly basic. Since it is infrequently used and can be easily made from scratch, it does not need to be saved in our adjustment set.

High-Contrast Version. You can use Photoshop's Channel Mixer to control the tonal conversion and contrast of various colors to produce a better separation and a more dramatic black & white image (or in some cases to create a separation between colors). This is an alternative conversion for black & white; it will be used less frequently.

1. Click on the tiny arrow button in the upper-right corner of the Actions palette. Name this action B&W Channel Mixer. Save this action in the Adjustment Set folder, but don't assign a function key. Click Record.
2. Create a Channel Mixer adjustment layer via Layer>New Adjustment Layer>Channel Mixer. In the New Layer dialog box, click OK. A second dialog box will then appear. Click on the box labeled Monochrome, then adjust the Source Channel sliders and Constant slider to

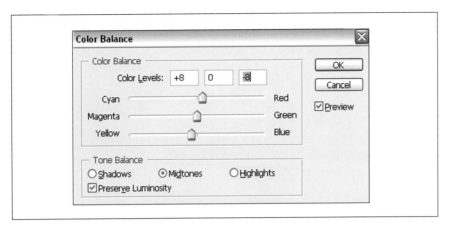

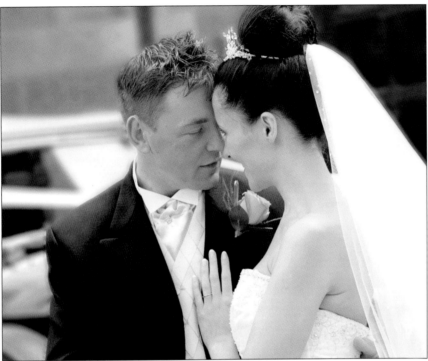

achieve the look you desire. Moving an individual slider to the right increases brightness and contrast; conversely, moving it to the left decreases contrast. When you are happy with your selection, click OK and stop recording the action.

When you look at the Layers palette, you'll note that by creating this action, we have created a new layer (Channel Mixer 1). If you are happy with the results at this stage of the process, go to Layer>Flatten Image. If the image is too contrasty, double click on the new layer and tweak the Contrast slider in the dialog box that appears. When the result is to your liking, flatten the image.

Sepia Filter
Now let's add a sepia-tone effect to the monochrome image we just created. With the image open, complete the following steps.

1. To begin, create a new action, name it Sepia, and assign the function key F3. Click record.
2. Go to Image>Adjustments>Color Balance (or use the shortcut Ctrl/Cmd+B). Click the Midtones radial button and adjust the midtones by moving the Cyan/Red slider to a value of +8 and the Yellow/Blue slider to –8. Click OK and stop recording the action.

Now when we press the F3 function key we can apply a slight warming effect to the image. The result is a warm-tone black & white image with just one key press. Press the key two or more times and the image will get progressively warmer. This is not the only way to create sepia images, but it's one of the quickest to apply in our workflow.

You may note that the image gets slightly brighter and shows more detail in the shadow areas but loses some extremely fine detail in the highlights. This is the effect of adding yellow to our image. Therefore, this action works best on images that are left slightly darker than normal before converting to mono. You may want to use this effect with the "muddy" black & white conversion method outlined above.

This filter also doubles as a "warmer upper." Sometimes color images can look a little cold, even when correctly color calibrated. Simply press F3 to give the entire image a warmer feel.

Controlled Tone Conversion. In this toning method, we will record an action containing an adjustment layer and add it to a new set of actions called Variants. This is because it essentially does the same as our F3 sepia action but is a variation of the same technique. This variant provides increased control over the toning effect. You can use this technique to create a variety of tones—sepia, blue, green, or any other tone you desire. If you tend to use a variety of tones when you're processing a group of images, record separate actions for each and assign a separate function key for each tone.

You can use this technique to create a variety of tones—sepia, blue, green, or any other tone you desire.

Hue/Saturation dialog set to value 210 for a blue tone.

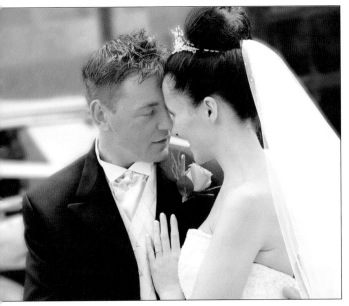
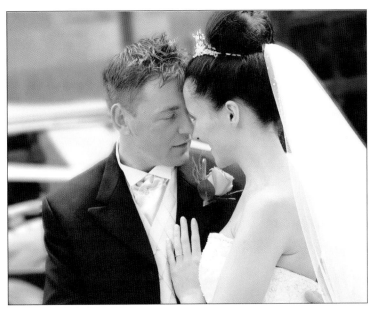
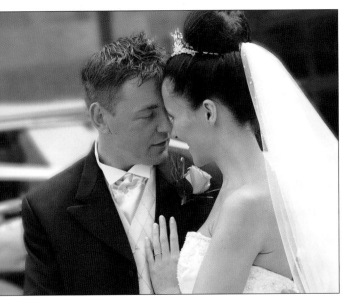
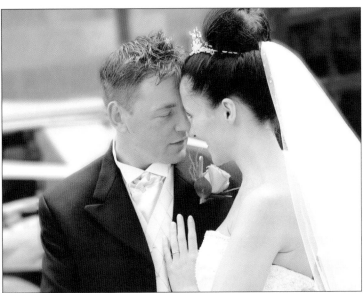

Top row—(Left) *Original monochrome. (Right) Sepia toned using a Hue of 45.* *Bottom row*—(Left) *Blue toned using a Hue of 210.* (Right) *Green toned using Hue of 100.*

1. To begin, create a new action, name it Blue Tone, and start recording.
2. Go to Layer>New Adjustment Layer>Hue/Saturation. In the dialog box that appears, click OK (the default layer name of Hue/Saturation 1 will be applied).
3. A second dialog box will now appear. Click on the check box labeled Colorize in the bottom-right corner of the box. A default tone will automatically be applied, but it probably won't be what you have in mind. If you'd like to add a rich blue tone, simply move the Hue slider to the right to select a value of about 210. Sepia can be found at around value 45, and green at 100. Use the Saturation slider to enhance or diminish the effect.
4. When satisfied with your chosen tone, stop recording.

Tom's Soft Focus Filter

The Gaussian Blur filter is a main component of many digital filters and plug-ins created over the years. I've found these filters too complex for my tastes, and was often unhappy with the results. I created my own version, of which I am quite proud. Try this one, and don't forget to add it to your main adjustment set.

1. Open an image that would benefit from a soft-focus effect.
2. Name the action, assign a function key, and hit Record.
3. Select the background layer in the Layers palette and drag it onto the Create a New Layer icon.
4. With the background layer copy selected, select Filter>Blur>Radial Blur.
5. In the Radial Blur palette, adjust the Amount to approximately 25. (Some trial and error may be required due to the resolution and size of your image. My images are generally formatted at 200dpi, and this figure works well no matter the finished print size.) Select the Spin blur method and Good quality before clicking OK.
6. Go to Filter>Blur>Radial Blur once more, but choose the Zoom blur method. Do not alter the other settings. Click OK.
7. With the background copy still selected in the Layers palette, change the blending mode from Normal to Screen and reduce the layer opacity to between 60% and 70%. This is just a starting point, we can adjust it later. We can see

Create new background layer (step 3).

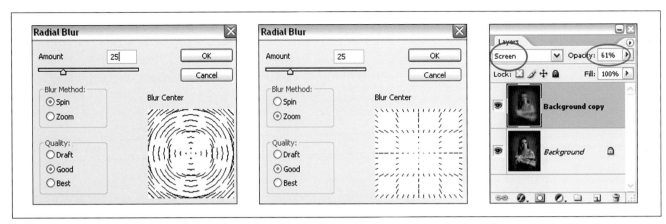

Above—(Left and Center) Successive applications of Radial Blur (steps 5 and 6). (Right) Changing the blending mode and opacity to produce the desired effect. **Left**—The final image.

that the filter adjustments have created the spreading of highlights found with traditional soft focus filters used in front of the lens.

8. Next, click on the original background layer in the Layers palette and select Layer>New Adjustment Layer>Curves. The new dialog box does not have to be named, just click OK. Grab the center of the curve in

the new palette and drag it down slightly to pull back detail in the shadow areas of the image that have been removed by the spreading of highlights.

9. At this point, stop recording the action.

The above selections will give a pleasing soft focus to almost all images. If you are happy with the results, flatten the layers and save the image. If more high-

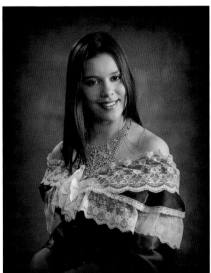

*Top—Adjusting the depth of the shadow tones. **Above**—Original image. **Right**— Image after soft focus is applied.*

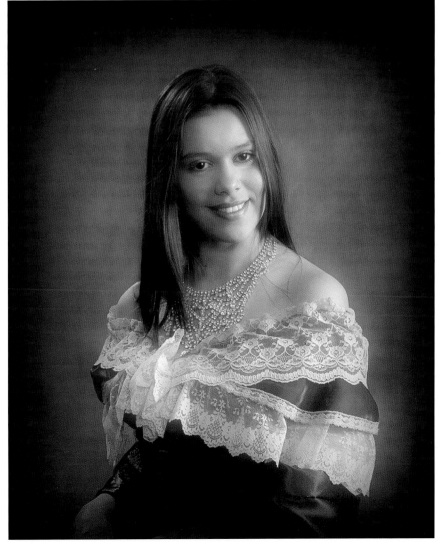

light or shadow intensity is required, select the relevant layer and make the required adjustments. To add more soft focus, select the background copy layer and increase the opacity to apply an additional spread of highlights. To adjust the amount of shadow detail, double click the graph in the adjustment layer to reopen the Curves palette and drag the curve up or down as required. Remember that the opposite adjustments can be applied to diminish the effect. When you're satisfied with the final effect, flatten the layers and save the image.

Sharpening

Some form of sharpening should be applied even if you think the image looks okay. In general, an image with more contrast will require less sharpening

Original image (left) and Smart Sharpen dialog box (above).

Above—*Function keys can be used up to three times for separate actions.* **Right**—*Image artifacts that are caused by oversharpening.*

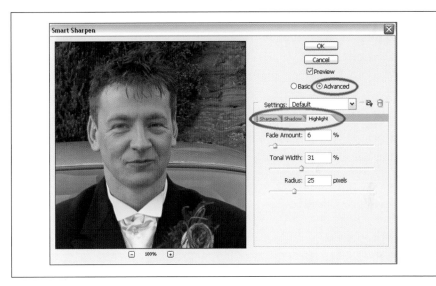

Additional options in the Smart Sharpen dialog are available for fine tuning.

than an image with a flatter look. This is why we turn off the auto sharpening at the capture stage (see chapter 5). Due to the destructive nature of sharpening, it should always be applied in one step, never in increments.

We are going to record two separate sharpening actions: one that uses the new Smart Sharpen filter available in CS2 and a more traditional method that can be used with older versions of Photoshop. These actions should also be recorded at various strengths of adjustment, so that they can be applied quickly and easily.

Smart Sharpen. The new Smart Sharpen feature in Photoshop CS2 is far superior to the Unsharp Mask. We can apply a small amount of sharpening to crisp up the file using all the original data.

To begin, open the image you wish to sharpen. (Let's assume the image has been converted from the original RAW file but the file size is exactly as it was captured. Let's also assume that the image is of average tone and contrast. Applying the filter on a cropped or resized file may have an adverse effect on the image, so only apply this to an original image.)

1. First, create a new action, remembering to add it to the adjustment set, and name it Smart Sharpen. Assign a function key, then click Record.
2. Choose Filter>Sharpen>Smart Sharpen and apply the default settings presented in the dialog box by pressing OK. The default setting is never harsh enough to damage any image and is usually all that is required to produce excellent results in the majority of images.
3. Stop the recording. That's all there is to it—nothing more, nothing less.

To produce additional levels of sharpening (Sharpening 2, Sharpening 3), increase the Amount by about 50 units each time. When assigning a function key, use the same "F" key as before, but click on the check box labeled Shift or Control (PC; Mac users can choose Shift or Command) to allow the use of the same key.

The degree of sharpening you apply will depend on the overall contrast range of the original image. To check the effect of your adjustment always view the image at 100% and check the areas of high contrast. If you can see halos or artifacts on the fringes of light and dark boundaries, then the image has been oversharpened.

The Smart Sharpen dialog box offers a range of options that will allow you to fine-tune the highlights or shadows, but for most images, this is not necessary.

> The degree of sharpening you apply will depend on the overall contrast range of the original image.

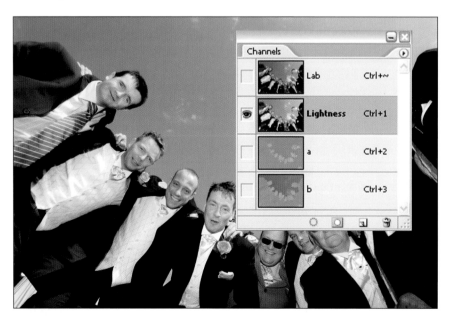 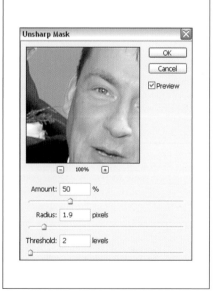

Left—*The original image in Lab mode and with Lightness channel selected.* *Right*—*The Unsharp Mask filter settings.*

Lab Mode Sharpening. To create a sharpening action with a version of Photoshop released prior to CS2, first open your image (which we will assume is one with good tonal range and contrast), then proceed through the following steps, adding the action to your Adjustments or Variants set.

1. Create a new action, name it, and assign a function key. Click Record.
2. Select Image>Mode>Lab Color.
3. Go to Window>Channels and click on the Lightness layer. You will notice the image turn to black & white, and the eye icon will appear only in the Lightness channel indicating that this is the only active channel.
4. Select Filter>Sharpen>Unsharp Mask and apply the following values: Amount = 50, Radius = 1.9, Threshold = 2. Click OK.
5. Next, click on the Lab layer in the Channels palette to activate the full Lab Color layer.
6. Change the mode back to RGB by selecting Image>Mode>RGB and stop the recording. Because we have only applied the Unsharp Mask to the Lightness channel, the effect of large amounts of sharpening is softened by the other layers, and the noise is reduced.

Adjusting the Shadows

Photoshop CS2 has a great tool for making adjustments to underexposed images and bright highlight details. If you adhere to the image capture guidelines provided earlier in this book, you'll rarely encounter such an image. However, there are occasions when one gets through, particularly if you're shooting in JPEG mode.

Shadow/Highlight Palette. Open an image with underexposed shadow areas and proceed with the following steps to create a one-touch solution for most images that lack shadow detail.

Photoshop CS2 has a great tool for making adjustments to underexposed images.

1. Create a new action, adding it to either the Adjustment or Variant set (depending on your preference), name it, and assign a function key. Click Record.
2. Select Image>Adjustments>Shadow/Highlight from the drop-down menu. In the dialog box that appears, you'll see the default settings of 50% and 0% in the Shadows and Highlights fields, respectively. The default settings were far too severe for this particular image, so we chose a Shadows setting of 22% and left the Highlights setting at 0%. Using this method is great for images that only require slight adjustment. However, you may want to create actions with various strengths of correction as we did for the sharpening action. (Note: You can access the palette's extended options by checking the Show More Options box. However, this makes heavy going in trying to fine-tune the image and can introduce unwanted noise in the shadows we are trying so hard to optimize. Going into this amount of manipulation defeats the objective

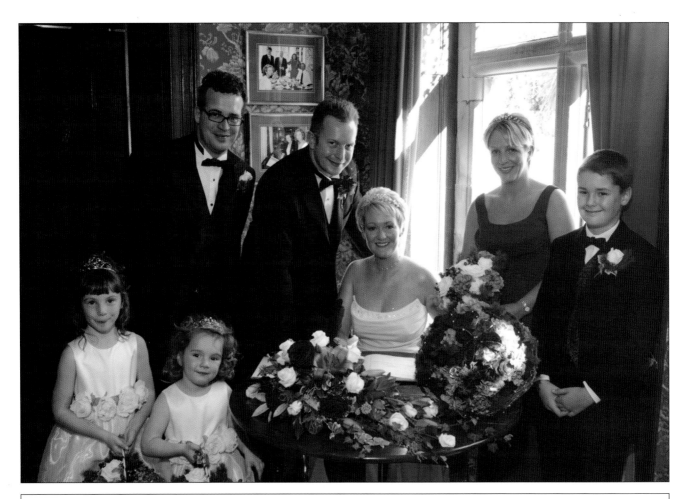

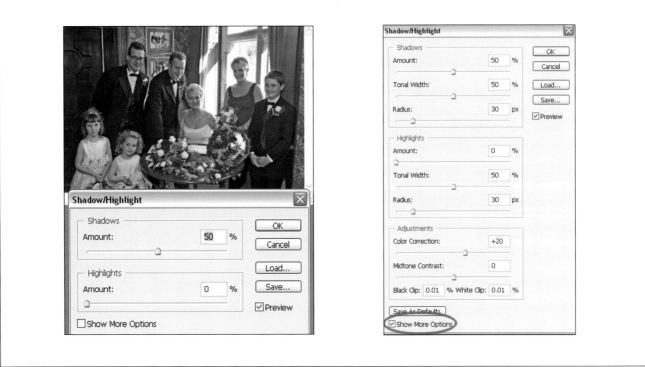

Top—*Original image with dark shadows due to the influence of bright highlights at the right-hand side of the image.* *Above*—*Standard Shadow/Highlight adjustment dialog box (left) and the advanced palette (right).*

of a quick and efficient workflow. If your image needs it, though, the tools are there.)

3. When the image is corrected, stop recording, flatten the layers, and click Save.

Quick Fix. An alternative to the Shadow/Highlight correction is an easy method that does not introduce significant noise—unless the image is so far gone that it probably doesn't deserve saving! To use this option, open the image and proceed through the following steps.

1. Create a new action, name it, and assign a function key. Click Record.
2. Duplicate the background layer by dragging it onto the Create a New Layer icon in the Layers palette. Change the blending mode to Screen and reduce the layer opacity to about 60%, then stop recording. Changing the blending mode to Screen lightens the entire image, and by re-

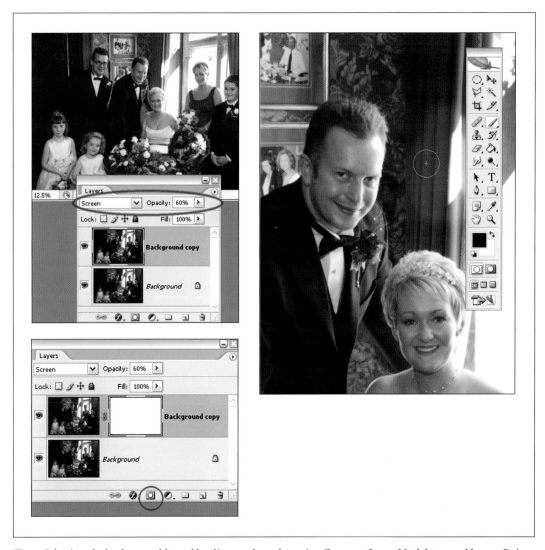

Top—Selecting the background layer blending mode and opacity. **Center**—*Layer Mask button.* **Above**—*Painting in the highlights to show the darker tones under the background copy layer.*

ducing the opacity, the background layer shows through, reducing the amount of noise in the image.

3. At this point in the process, the individual layers are intact. If everything looks good, flatten and save the image. However, because Screen mode is a global solution, some of the highlights may appear blown out. In this case, do not flatten the image. Instead, click on the Layer Mask icon (the square with the circle in it at the bottom of the Layers palette) and choose a suitable soft-edged brush, change the foreground color in the toolbar to black, and "paint" in the highlight areas to bring the original detail back by exposing the background underneath. If you overdo the painting in of highlights, select a white foreground color in the toolbar and hide the layer below by painting the shadows out. When you're satisfied with the results, simply flatten all the layers.

A "rescued" image using five successful passes of the Shadows action filter, followed by conversion to black & white, then sepia toned.

This action can be applied multiple times and can render throw-away images usable. Treat severely underexposed JPEGs with three or more applications of the action, then run the Mono action to produce a grainy but "atmospheric" image with an artistic feel, similar to that produced with a high-speed black & white film.

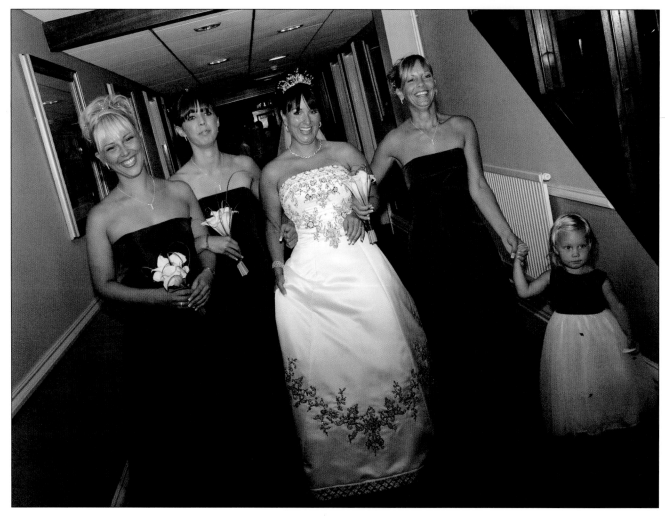

Increase the color saturation in the Hue/Saturation palette.

Saturation

Photographers shooting with transparency film often underexpose by a half a stop to increase saturation. With digital, we can create an action that employs the Hue/Saturation feature to increase the impact in our images. Here's how:

1. Open an image, then create a new action. Name the action, assign a function key, and hit Record.
2. Open the Hue/Saturation palette (Ctrl/Cmd+U) and move the Saturation slider to +10. Click OK to apply the setting, and stop recording.

Note that the color saturation can be increased in increments by pressing the function key again, but use caution: if your image features subjects with a reddish skin tone, they may take on a "beetroot" look, and the image may then require color compensation (and this defeats our objective of creating a quick fix!). When you're satisfied with the results, simply save the image.

Rotation

Rotating an image is one of our most repetitive tasks. Simply record one action for rotating the image clockwise and another for counterclockwise.

1. Open an image, then create a new action. Name the action, assign a function key, and hit Record.
2. Go to Image>Rotate Canvas>90° CW, then click Stop.
3. Next, repeat step 1, assign the same function key, and click either the Shift or Control (Command for Macs) check box and click Record.
4. Go to Image>Rotate Canvas>90° CCW, then click Stop.

Top left—Reducing the size of the background layer copy (step 2). ***Bottom left***—*Applying the Stroke options.* ***Above***—*Selective enlargement showing the applied stroke.*

Album-Specific Actions

Digital photographers often double as album designers. Though album design will be covered in more detail in chapter 15, we'll cover two useful album-specific actions here. These should be added to a new set labeled Album Set.

To create a three-dimensional effect that appears to "lift" the images off the page, create and apply one of the following actions.

Stroke/Drop Shadow. In order to record this action, we need to open a "donor" image. It doesn't matter what it is, because we are not going to save the resulting image, just the action.

1. Drag the background layer onto the Create a New Layer icon to create a background copy layer.
2. Next, we'll reduce the size of the background copy. Press Ctrl/Cmd+T to select the Free Transform tool.
3. Press the Shift+Alt/Opt keys down, click on one of the corner handles of the Free Transform tool, and pull toward the center of the image so that a margin appears around the copy layer. Hit Enter to apply the

change. (In our sample we brightened the background layer so that you can see the effect more clearly.)

4. At this point, create and name the action, assign a function key, and click Record.

5. Go to Edit>Stroke and enter a Width of 2 pixels for a thin keyline or 5 pixels if a wider line is preferred. Select a color for the stroke. (You can choose a color to complement the image, but white will suffice for the majority of images. Remember we are trying to build a series of actions that are repeatable and fit in with the type and style of our work. Create separate versions for variants of this action.) The location of the stroke should be inside the image. This creates crisp, sharply defined corners without rounding of the pixels. Keep the blending mode set to Normal and the opacity at 100%. Click OK to apply the effect.

6. Adding a drop shadow will help to visually lift the image off of the page. Click Add a Layer Style (the curly "f" icon at the bottom of the Layers palette) and choose Drop Shadow. The style of the shadow is affected by the various sliders in the Layer Style palette. This is a matter of preference, but softer shadows seem to work best. Try applying the following combination: Angle = 45, Distance = 25, Spread = 20, and Size = 70. Click OK.

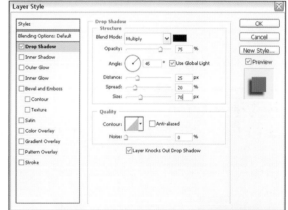

Aboe left—Adding the drop shadow layer effect (step 6).
Above right—Drop shadow filter settings. **Bottom—***The final stroke and drop shadow effect.*

7. Stop the recording. The donor image can now be deleted. The action has been successfully recorded and can be applied in your album design workflow.

Pillow Emboss. To add this effect to your image, open a donor image as described in the "Stroke/Drop Shadow" section on the preceding page. Simply complete steps 1–3 in that section, and then proceed with the following steps.

1. Click on the Add a Layer Style icon and choose Bevel and Emboss from the available selections. The Layer Style palette opens again giving us a myriad of sliders and controls to choose from. Make the following selections: Style = Pillow Emboss, Technique = Smooth, Depth = 50, Size = 40, and Soften = 5.
2. Click OK if you're satisfied with the result, or rerecord the action if you prefer a stronger effect.
3. Stop recording and delete the donor image as we did above.

So now we have all the ingredients for taking, converting, and processing images, without it taking three weeks to complete. We've created a lot of ac-

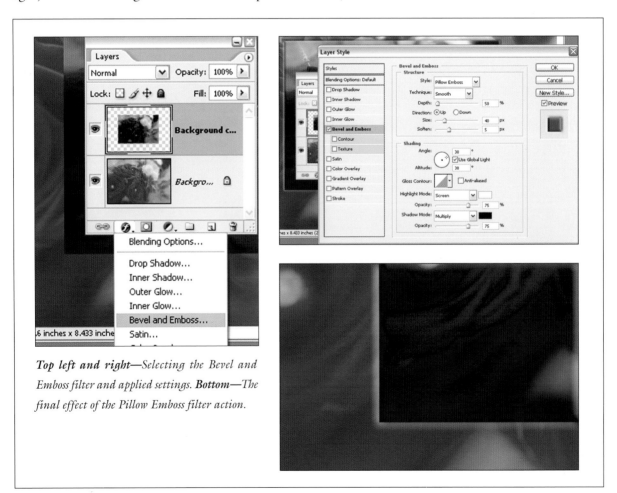

*Top left and right—Selecting the Bevel and Emboss filter and applied settings. **Bottom**—The final effect of the Pillow Emboss filter action.*

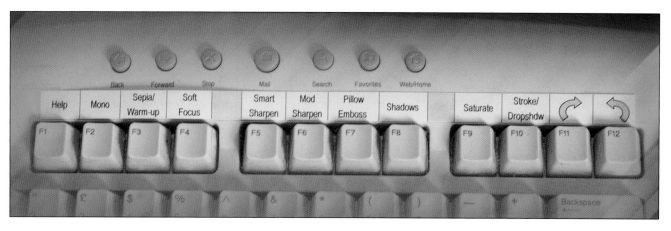

*Above—Paper label strip above the function keys. **Right**—The Actions palette in Button mode. Note the assignment of function keys.*

tions and have assigned many function keys. Remembering which key does what can be frustrating, so create a cheat sheet. Make a paper strip label like the one shown on this page and tape it above the respective function keys. Job done!

ADDITIONAL PHOTOSHOP TECHNIQUES

Actions can be used to turn out high-quality images quickly. Of course, some images may require some special attention. The following techniques can help you create outstanding images that deserve printing at larger sizes.

Below, we'll look at the capture and processing used to produce a low-key portrait similar to an Old Master painting using a chiaroscuro effect. This will give you a feel for how a single image can be efficiently captured and finessed post-capture.

Chiaroscuro

This term comes from the Italian words for light (*chiaro-*) and dark or shade (*-scuro*) and basically means the way we create three-dimensional depth from a two-dimensional object or surface. It was used by the Renaissance painters and often referred to as Rembrandt lighting, after the Dutch painter who used it extensively.

When we look at the work of the Old Masters, we note that quite often the edges and deep shadows of the paintings tended toward black and dark browns, greens, and the like. If we were to apply a histogram to their images, they would be heavily stacked in the shadow areas—yet the paintings are vibrant and powerful.

If we were to apply a histogram to their images, they would be heavily stacked in the shadow areas. . . .

Capture and Adjustment

With the camera set to the RAW mode, we captured a reference image incorporating the ColorChecker (as described in chapter 7). We then proceeded to create a variety of poses.

Once the session was complete, we download the images into a folder labeled Vivienne and opened Adobe Bridge, selected all the images, and dragged the files into Photoshop. This automatically opened the Adobe Camera Raw file processing software.

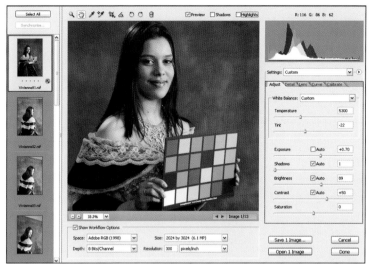

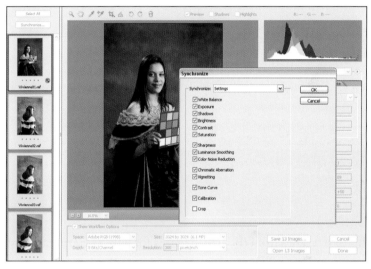

Top row—*The portrait selection in Bridge (left) and reference photo in Camera Raw (right).* **Bottom**—*The collection is synchronized to the reference image after adjustment.*

As you can see in the screen shot, the auto function of the file processing software assumed the images were underexposed and tried to compensate for it. Of course, we know that the image is low key and should be darker. Therefore, some adjustments were necessary.

After adjusting the reference image, we chose Select All>Synchronize; as the lighting in our session remained constant, all the changes to the remaining images were identical.

Batch process all the images into 8-bit JPEGs and save them in the same folder. The batch process automatically creates a new folder called JPEG. Select a suitable file to work on and open it.

Vignetting

To create a vignette during image capture, photographers must ensure that the aperture of the vignetter suits the focal length of their selected lens. This becomes a problem with zoom lenses, where the focal length can vary from one end to the other.

Fortunately, applying vignettes in Photoshop couldn't be easier, and you can apply a low or high key vignette in any shape (rectangular, elliptical, star, etc.) in seconds.

1. To begin, choose one of the Marquee tools and select the area of the image around which you want the vignette to appear. (You can use the arrow keys to move the marquee to the left, right, up or down.) In the Options bar at the top of the screen, enter a Feather amount of 200. This works well with most images 8x10 to 16x20 inches. A smaller feather radius is used for smaller images. The maximum feather that can be applied is 250 pixels, so several concentric vignettes must be applied to create the effect for very large images (30x40 inches).

2. We must now invert the selection. To do this, simply go to Select>Inverse (Ctrl/Cmd+Shift+I) to select the area where the vignette should appear. Note too, that the feather effect, which was initially applied inside of the selection now appears on the outside of the selection marquee.

3. Next, go to Image>Adjustments>Hue/Saturation (Ctrl/Cmd+U) and move the Lightness slider all the way to the left to create a low-key vignette, or all the way to the right to make a high-key vignette. When you're satisfied with the results, click OK.

The image has now been selectively vignetted with a soft-edged marquee, giving us a classic low-key portrait.

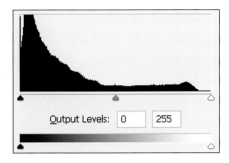
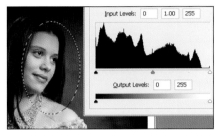

Left—*(Top) Histogram of the entire image showing a heavy concentration of colors in the shadow areas. (Bottom) Face mask histogram showing good distribution of color and detail in the main area of the image. **Center and right**—Comparison of original and vignetted image.*

Face Mask Histogram

In chapter 3, we discussed the relative merits of differing types of histogram but also outlined the ways in which they can be deceiving. The sample histogram shown above shows a full range of tones from highlight to shadow. As you can see, the majority of tones in the histogram are concentrated in the shadows. This is what we might expect to see in a Rembrandt-style portrait. The important sections of the image are, however, in the face and surrounding areas of the head. The darker areas of the image draw the viewer's gaze toward the center of the frame where the main focal point lies.

In order to check that we have the right exposure and good detail in the important areas of the image, we use what is referred to as a face mask histogram. From the toolbar, select an elliptical Marquee with a feathered edge (say 5 pixels) and draw a selection around the face, taking in some hair, background, and highlight detail.

Open the Levels palette (Ctrl/Cmd+L) and revisit the histogram. In the face mask histogram shown above, we can see that there is a wealth of information throughout the selection, indicating great tonal range in the area we have selected.

Though our image is good enough to print at this stage, and the client would probably be very happy with the result, we can improve on our portrait, making it more closely resemble a portrait from the Old Masters.

Plug-in Filters

A carefully chosen plug-in filter can be an asset in your workflow. It's worth noting, though, that there are a number of enticing filters on the market that really don't offer much improvement for the time you spend fine-tuning the sliders. Artistic filters are a case in point.

> There are a number of enticing filters on the market that really don't offer much improvement. . . .

There is one set of filters that seem to live up to their claims and are generally intuitive in their use. Nik Color Efex Pro's Midnight filter was used to create the image on page 100.

Because the bride is 6 inches taller than the groom, a creative "tilt" was used in camera to even out their respective heights. Unfortunately, the camera tilt is evidenced by the sloping verticals of the window frame in the background. The image was lighted with daylight from the window, supplemented by a blip of fill-in flash.

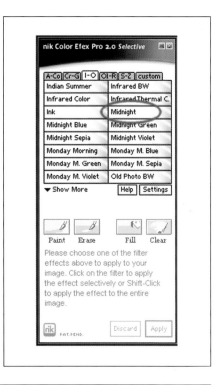

To finesse the portrait, we used the Smart Sharpen action created in chapter 12, then cropped and resized the image. Next, a vignette was added (as was described earlier in this chapter).

With these steps complete, we applied the Midnight filter. This filter is applied much in the way that an action is played when the Button Mode is selected. A simple dialog box opens showing a preview image with the default settings applied. Although there are options for adjusting Blur, Contrast, Brightness, and Color, we don't want to spend hours tweaking controls, so we just click OK to apply the default settings.

The image does not show any changes at this point, but the Layers palette shows an adjustment layer ready to apply changes to.

In the Nik filter palette, click the Fill button to show the results of applying the filter. The result is quite dark and dramatic, but lowering the opac-

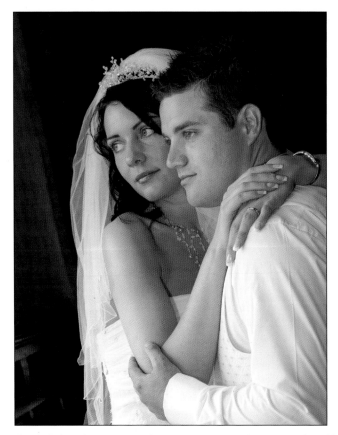

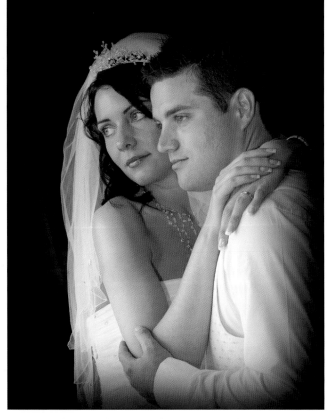

Top—*Nik Color Efex Pro plug-in interface.* **Left**—*Original wedding image.* **Right**—*Adjusted and vignetted similar to our previous portrait.*

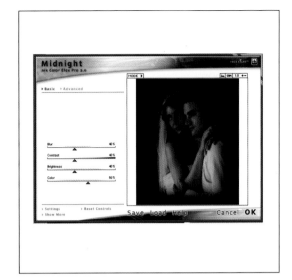
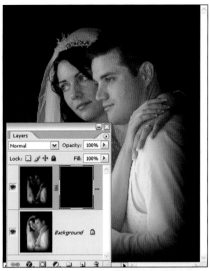
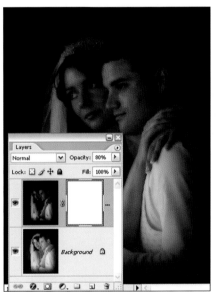
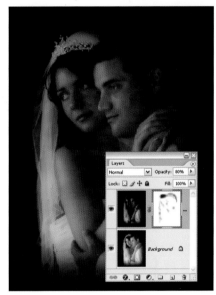

*Top row—(Left) Midnight filter dialog box. (Right) Layers palette showing adjustment layer. **Bottom row**—(Left) Clicking the Fill button in the Nik palette changes the layer properties. (Right) Using the Erase feature in the Nik palette allows painting back detail in the layer mask.*

ity of the adjustment layer in the Layers palette can reduce the effect. In this example, the opacity was reduced to 80%.

Because the filter has not been finalized, we can paint in areas of highlights to the layer mask. Return to the Nik palette and click the Erase button. We are now painting in black onto the layer mask, revealing the original image underneath. Reduce the Brush opacity to about 15% and gently paint in areas of highlight or separation (tiara, veil, profiles, rings) to sculpt around the subjects until the desired result is achieved.

Once you're satisfied with the results, click the Apply button on the Nik dialog box to implement the effect and flatten the image layers. Applying the Midnight filter tends to give the image a flat feel, but the problem is eas-

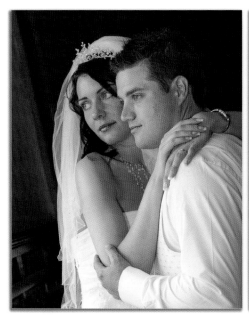

Original (left), midnight (center), and sepia-toned (right) versions of the image.

ily rectified by one click of the Sepia/Warmup and Saturate action function keys. We could use the Mono action followed by several clicks of the Sepia action key to create yet another version of the image.

Eye Makeover

If there is one area of a portrait that can make or break an image, it's the eyes. There are several ways that they can be enhanced, and a combination of techniques used by Charles Green and Jane Conner-Ziser works well on almost any image.

We can play around with lights forever to get that perfect modeling, but occasionally though the main picture looks okay, the eyes have just missed out. Our sample image is going to get the 3-D treatment! The image has two catchlights, which is generally considered a no-no, and the whites of the eyes are a little dull, so we'll clean them up.

To begin, enlarge the image so that both eyes are large in the screen. Never work on one eye at a time or you will end up with an imbalance in the image. Choose the Clone tool and reduce the opacity to around 10%. Using the Color Sampler, choose a selection from the pupil and the iris next to the unwanted highlights and begin painting the existing catchlights out.

Select the Create a New Layer icon in the Layers palette and choose a soft-edged brush, just smaller than the size of the iris, set to 100% opacity. Ensure the foreground color in the toolbar is set to white and paint in the whites of the eyes.

Don't worry if the overspray covers other sections of the image. Reduce the opacity of the layer so that you can see the iris and outline of the eyelids and begin erasing the overspray with a soft-edged brush. The brush should be soft enough not to create a hard edge but hard enough for the fill not to

Never work on one eye at a time or you will end up with an imbalance in the image.

Original image.

look mushy. The layer is then reduced to 0 opacity and slowly brought back to give a pleasing result. It sometimes helps to zoom out a little to see the whole of the face in order to get a better impression of the effect.

Zoom back in to see both eyes large again and create another new layer. Use a soft-edged brush, again set to white and 100% opacity, about the same size as the pupil, and place a new catchlight in the corner of the pupil and spreading into the iris. Let it go slightly larger than you need because we are going to shape the catchlight.

To give the catchlight some semblance of realism, we shape the catchlight with a soft-edged Eraser tool as if the light was coming in from a square-shaped window, slightly curving the top to add shape to the eye. As before, zoom out to see the whole of the face and reduce the layer opacity to 0. Slowly bring back the layer until the desired effect is achieved.

The last phase of the makeover gives the eyes the real 3-D look. Using the Color Sampler tool, select a color in the iris opposite the catchlight and go to Window>Color. Increase the saturation and brightness to produce a vivid color. Using a soft-edged brush again, draw some half moons into the iris opposite the catchlights, overspraying into the pupil.

Paint out the catchlights.

Adding white to the eyes.

Adjust the layer opacity to get the best effect. By adding the effect on a separate layer you can alter it later in the process.

Place the catchlight in the area where the iris and pupil meet and shape it with a soft-edged Eraser tool.

We need to shape the iris color again, but this time use a hard-edged brush to erase the area next to the pupil. Use Gaussian Blur set to 1 to knock some of the hard edge off the colored fill. Lower the layer opacity to 0 again, and slowly bring it back until you are happy with the result. Once done, the layers can be flattened.

Select a color from the iris and enhance its color and saturation.

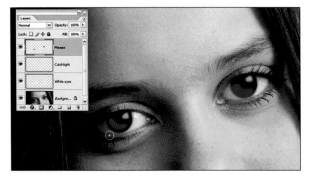

Shaping the "moons" of the iris.

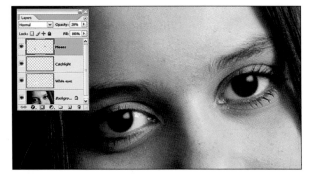

The transformed image.

PRESENTATION

Sure, photographers shooting digitally tend to take more images than do film photographers. We also tend to experiment more than we ever used to. Unfortunately, the problems of copyrighting and protecting photographers' work from theft are more prevalent than ever.

There are a few methods of previewing that allow us to exercise a small measure of control over the distribution of our work, reducing the possibility of clients copying our images. Two immediate solutions to the problem of copyright theft are simply to charge enough for your services up front so that the theft of your work does not worry you, or simply don't let the work out of the studio!

Unfortunately, both solutions present problems. Setting high prices to counter the effect of image theft on your profits can keep clients from using

A password-encrypted website allows purchases online and protects the photographer's copyrighted work.

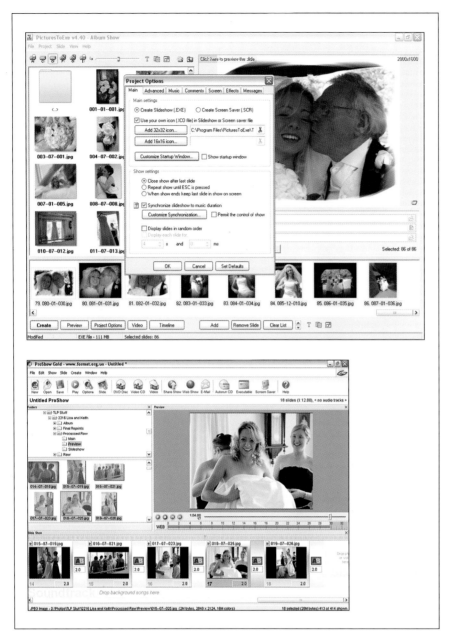

Pictures to Exe and Proshow Gold Media interfaces allow presentations to be made for PC in entirety or in separate chapters (arrivals, ceremony, reception, etc.), and the resulting shows can be saved as DVD movies.

your services. An in-studio preview presentation may not be convenient for you or your client, and generally takes up a lot of precious time. Also, unless you arrange multiple preview sessions, the number of people who can attend the session will be limited by the size of your studio.

Let's face it: if someone wants to steal your work badly enough, they will do it. All we can do is make it as hard as we can for them so it's not worth the bother.

Websites

One of the more popular methods of previewing is to upload your work to an encrypted website, allowing anyone with an access password to view thumbnail versions of the photos, select their favorite shots, and purchase images. This option offers the advantage of allowing friends and family world-

wide to view the clients' images and place their own orders. Depending on the host site, you may be charged a yearly fee, an upload fee, or an online purchase percentage.

Drawbacks of this method of presentation seem to be limited to the quality of the preview images and the size of the image viewed. Facial expressions are hard to make out on group shots if the images are not of a reasonable size.

Preview Albums

Preview sample albums, though generally not favored these days, are still a viable means of previewing images. The most common form of protection is a copyright watermark across the middle of the image. Unfortunately, this tends to diminish the impact of some images and can lead to lost sales. The client, however, can take the samples away to view them at leisure and show them to other family members.

Preview sample albums, though not favored, are still a viable means of previewing images.

Slide Shows

In days gone by, studios would have slides made from their negatives and give audio/visual presentations. The current trend is to create an audio/

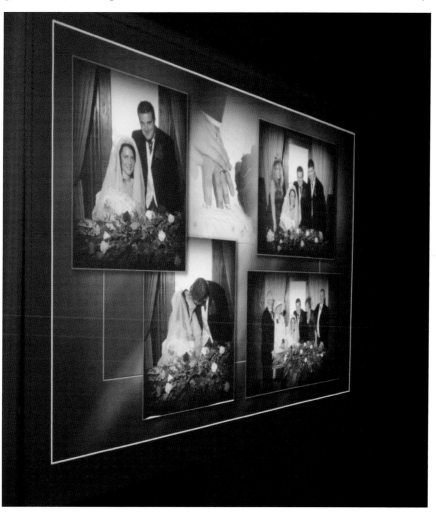

A projected DVD presentation.

visual presentation comprised of music and images, whether digitally projected onto large viewing screens or played on a laptop computer.

There are a number of programs available for PC and Mac that allow you to burn slide shows to CD or DVD in seconds. Proshow Gold, Pictures to Exe, and iMedia are probably the best known of these and allow you to encrypt the slide shows with a date of expiry and also have them password protected if required. Once the disc expires, the client has no option but to return to the studio for reprint orders.

Images can be previewed at high quality, and the average client has no means of copying individual pictures because they are contained in an executable file. This preview option offers still another benefit: you can make several copies of the disc for distribution to family members. Nonencrypted slide show discs also make a nice add-on to the main order.

The music for the slide show can greatly affect the sale of your images and should be chosen carefully to suit the mood of your imagery. Remember to use copyright-free music. Fees for copyright-free music and the terms under which it can be used vary greatly, but most music can be "previewed" on the sellers' websites and purchased online. Probably the best known of these sites is www.themusicbakery.com. Individual tracks can cost approximately $40, but the music is of a high quality—the days of "plinkety-plonk" MIDI files are thankfully gone forever.

Nonencrypted slide show discs make a nice add-on to the main order.

ALBUM DESIGN

Today's album designs are more innovative and individualized than they were in the past.

Album design has come a long way. Placing an 8x10-inch print behind a card overlay just won't cut the mustard anymore. Brides just don't want what mom and dad had, and the photojournalistic approach to wedding storytelling is taking off in a big way. Today's couples demand more pictures, dynamic pages, and exciting album designs.

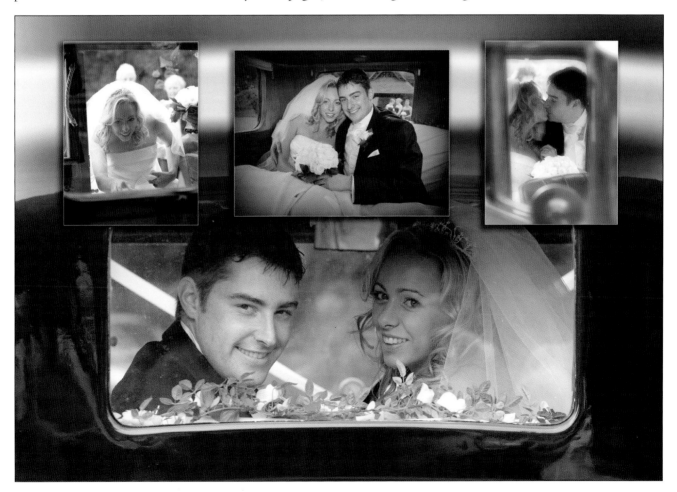

The design of modern wedding albums is another skill that the hard-pressed digital photographer must learn. Though you can hire an individual or company to design your clients' wedding albums for you, there tends to be an impersonal feel to the final product. Of course, you must also cover the costs of farming out the work.

There is a satisfaction that comes with nurturing the images from creative inception to the album, the final work of art. When you do your album design in-house, you are providing your clients with a little old-fashioned service that many companies lack.

Designing the album in-studio need not mean that you have to sit at your computer and hammer away at the design, employing every artistic effect under the sun. Why not design the layout and let a competent employee finalize the artwork based on your direction?

Below, we'll cover an album design workflow that will help you get through this process with little pain. In this chapter, we will assume that you intend to do all the design work yourself, and we will run through some of the tools to help you design the album.

First, let's get some computer savvy. It's important to divide your job file into several folders, as shown in the above chart.

A selection of images in Adobe Bridge ready for selection.

Design Services

Graphistudio products are popular with many photographers. The company makes a range of album sizes and also offers a print-and-bind service that allows the photographer or designer full creative control over the look of the album while leaving technical aspects of the album production to the company. The company also offers a full design service (with a limited input from the photographer) for those who are not inclined to tackle the album design in-studio.

Setting up a canvas template using File> New from the Photoshop drop-down menu.

Open Adobe Bridge and Photoshop in tandem. Now that the job folders have been set up, we can convert the RAW files into working images. Process the separate media card folders into a single working folder of individual images and use Adobe Bridge as a digital lightbox. Images can be clicked and dragged into chronological order within the thumbnail palette, and you can then add a sequence number to the file names.

Once the client has made the choice of album size, we can set up a blank canvas. Each album manufacturer will give specific details as to the amount of "bleed" required around each image, so that they can trim back the pages before binding. If the album manufacturer also prints your pages, you will need to know the exact resolution of the saved page files and the ICC profile requirements (Adobe 1998 or sRGB). A resolution of 200dpi is adequate for the printing process at this size. Our pages are formatted with the Adobe 1998 profile.

Next, we will need to determine the center of the double page. We don't want a portrait subject's eye positioned in the gutter of the page spread. Click Ctrl/Cmd+R to bring up the rulers at the edge of the image window and simply click and drag from the ruler across the page. This will position a guide onto the canvas, and the default settings will snap the guide into position when it reaches the center of your double page. If this does not happen, make sure the Snap function is selected in the View>Snap drop-down menu.

We also need to determine the "safe" edges of the page to prevent losing important areas of the print that appear too close to the edge. Drag a new guide and position it approximately ¾ inch off the edge of the canvas. Repeat the process until you have positioned several guides. Placing the guides will not be necessary as you become more familiar with laying out pages.

We now have a blank canvas with guides to help us position the individual images. When we open Adobe Bridge, we may find that some of the images from the session or event are not required for the album. To hide the unnecessary images from view, access the Label menu and tag the images chosen by the client or designer with a color or star rating. To display or hide a group of images, click the Unfiltered button in the top right of Adobe Bridge and decide what you require in view.

Next, choose the images you require for your layout. Hold down the Ctrl/Cmd key, select the images in Bridge you need for the page layout by clicking, then drag them over to Photoshop as a group, and we can move on to positioning. There are many ways of transferring images, placing images, and resizing within Photoshop, but covering all the different methods would require another how-to Photoshop book. The methods described here may

Top row—Determine the center of the two-page spread (left), then create a "safe" space by dragging guides onto your document (right). **Bottom row—***A "tagged" image with a yellow label (left). Click a "floating" image and drag it onto the empty canvas (right).*

appear basic, but sometimes simple is best—and the procedure adopted in the remaining sections of this chapter are used with this in mind.

We now have several "floating" images in Photoshop. To move an image onto the album page, use the Move tool and click and drag each image onto the empty canvas. This automatically copies the original image and places it onto a new layer.

We can use the Free Transform tool to resize and position the image on the page. Press Ctrl/Cmd+T to place a transform box around the image on the active layer, hold the Shift key and drag one corner of the transform box; the Shift key constrains the proportions of the image during resizing. If the corners of the bounding box are not visible, press "F" on the keyboard to show a larger working space around the canvas. Press "F" twice more to get back to the smaller window and reveal the other images to be used on the page.

This process is repeated for all images to be used in the page spread.

A couple of things to note at this point: If you resize an image a second time, you will undoubtedly get some image degradation. You are better off starting with a fresh copy of the image and dragging a new version over to the canvas. Alternatively, you can create a smart object from the transferred

image. Before resizing, click the arrow in the top-right corner of the Layers palette and select Group into New Smart Object. This effectively creates a container that embeds the image data, allowing you to perform certain functions such as resizing nondestructively.

Lining up images couldn't be easier. Photoshop's new Auto Align feature snaps images into alignment with others even in differing layers, based on a center, top, bottom, or edge position (this option is turned on as a de-

*Top left—Resize the image using the Free Transform command. **Bottom left**—The remaining images are added and resized in the same manner as the first. **Bottom right**—Creating a Smart Object.*

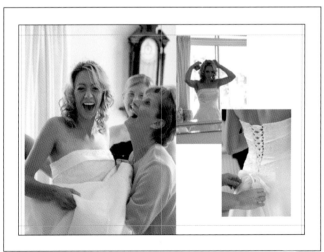

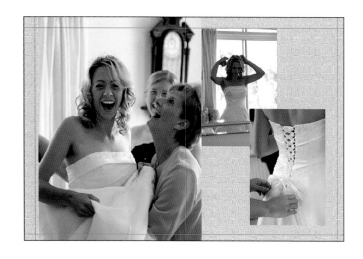

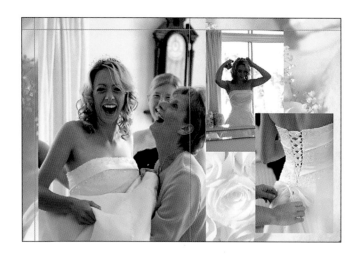

fault setting). Alternatively, just drag another guide onto the page, and the new image simply snaps into registration.

The background content of our page looks pretty boring in white, so we need to perk it up a little. There are a few of ways we can do this. A common method is to fill the background canvas with a pastel color and apply a texture to it. Pick a foreground color that complements your image selection, choose the Paint Bucket tool from the toolbar, and then click on the canvas. Next, go to Filter>Texture>Texturizer, select a texture, and apply it to the background layer by clicking OK.

Another option for adding some background interest is to drop a photograph of champagne bottles, glasses, presents, or the room in which the ceremony or reception was held onto the background layer and lighten it so that it doesn't overpower the other images on the page. With the image in place, press Ctrl/Cmd+U to bring up the Hue/Saturation palette and ad-

just the Lightness slider to give an almost transparent view of the image. If desired, a texture pattern can be placed over it as we did with the previous examples.

My personal preference is to create a blended background. The best way to achieve color harmony is to select the dominant image on the page and complete the following steps.

1. First, identify the layer upon which the selected image appears in the Layers palette and drag the layer onto the Create a New Layer icon. Next, move the new copy layer just above the background layer in the palette. This will position the image behind the other images in the layout.
2. Using the Free Transform (Ctrl/Cmd+T) tool, resize the image by dragging the handles of the bounding box so that the image completely fills the background. It doesn't matter if the proportions aren't correct, because we are going to distort the entire image beyond recognition.
3. Go to Filter>Blur>Motion Blur and apply a 45-degree blur amount and set the distance to 999. Click OK. This will streak the background be-

*Top—The dominant image copied and moved above the background layer in the Layers palette, then resized using the Free Transform function. **Bottom**—Blending the background image using the Motion Blur filter (step 3).*

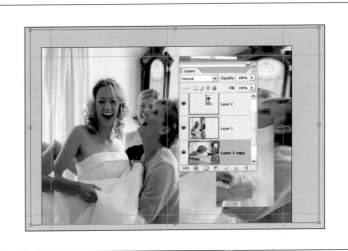

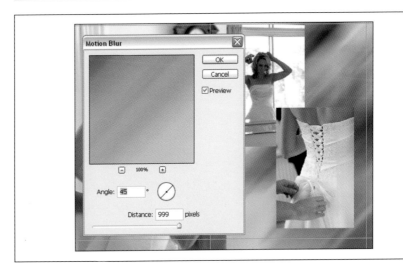

yond recognition, but the effect is generally too sharp to blend with the other images on the page. Just add a little Gaussian Blur to take the edge off it!

4. To blend the unaltered primary image with the new blended background canvas, select the rectangular Marquee tool and set the feather amount to 200. Select the layer containing the unmodified primary

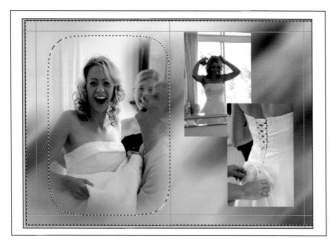

Top row—(*Left*) *Blending the primary image (step 4).* (*Right*) *The Auto Select Layer function appears in the Options bar when the Move tool is selected.* **Bottom**—*The completed page layout.*

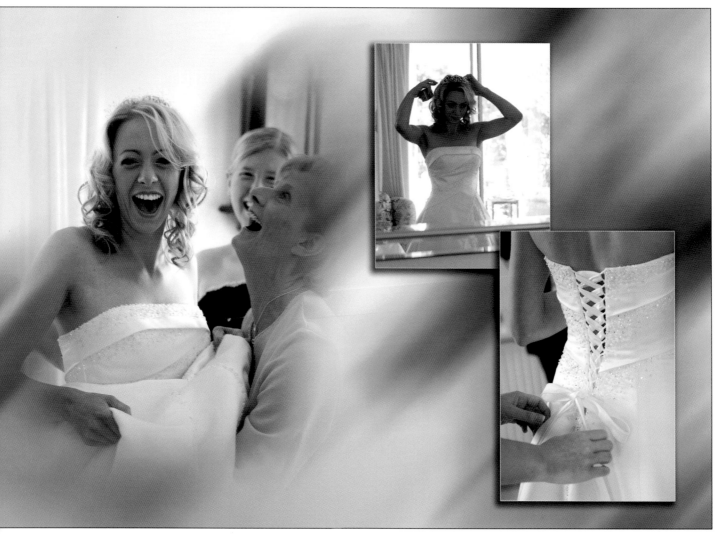

image and make a rectangular selection about an inch inside the edge of the image. Choose the inverse of the selection (Ctrl/Cmd+Shift+I) and press the Delete key three times. This gives a soft transition between the dominant image on the page and the background canvas. The primary image and the blended background have the same tonal value, creating a harmonious presentation.

In chapter 12, we created a Stroke/Drop Shadow action. To apply the effect, simply click an image with the Move tool and press the appropriate function key. Repeat the process for the remaining images, and suddenly the page is transformed into a custom-made work of art without the need for expensive plug-ins and design programs.

Finally, we have a finished double page. Remember that sometimes less is more; keep the number of effects you use to a minimum, and don't over-crowd your pages because they can look too fussy. Adhere to the KISS principal (Keep It Simple, Stupid) and you won't go far wrong.

Auto Select Layers

With the Move tool selected, you will find in the Options bar an option to Auto Select Layer. With this control is checked, simply clicking on the image you desire to work on will select the relevant layer.

PREPARING FOR PRINTING

In *Animal Farm,* George Orwell wrote, "All animals are equal, but some animals are more equal than others." The same can be said for printing labs and inkjet printers.

Although labs will insist that they are working to the tightest of quality control, you would be amazed at the difference in quality you can receive depending on the machines used, different operators, and the methods by which they calibrate their machinery. Based on the assumption that your own equipment is correctly calibrated, there are a number of precautions you can take to ensure that what you are getting back from the lab is correct.

If you suspect that color casts are creeping into your finished images, you need to be sure it isn't your equipment that is at fault before you complain. The simplest method for doing this is to include a pure black & white image with good tonal range with each order (preferably the same image with each order).

Open a good quality image that has an average histogram (not high or low key) and use your Mono action to create a pure black & white image. If there is no cast on screen, then your monitor is displaying neutral colors. Check this by clicking on the Color Sampler tool and roam over your image. The Info palette should display equal values in the Red, Green, and Blue channels. Remember that the computer sees numbers and not colors. If the RGB values are equal and your screen has a slight cast, then you are probably to blame and the screen needs recalibrating. It may not, however, be that obvious due to the fine line between what the computer says is right and what our eyes can see.

> If the black & white image is off but your RGB values are okay, the color problem is the lab's fault.

The real test is the quality of print that comes back from the lab. Check the monotone image for a color cast. If the black & white image is off but your RGB values are okay, then the color problem is the lab's fault.

You can also evaluate the prints from your inkjet printers to determine whether a color cast is the fault of an improperly calibrated monitor or

Top—A neutral black & white image, confirmed by the values of the RGB channels in the Info palette. **Above**—*A test print for finding the tonal range of your printer.*

printer. Be advised, though, that calibrating an inkjet printer should be left to those with the correct equipment to build the ICC profiles for each of the media being printed on. Note that inkjet prints may suffer a little in tonal range when compared to wet prints, but the technology gets better almost daily.

To find the tonal range of your printer, make a test print that is 4x6 inches at 200dpi, then complete the following steps.

1. Create a black strip at the top. This should have RGB values of 0, 0, 0.
2. Create a white strip with the RGB values 255, 255, 255.
3. Below the black bar, use the Text tool to type in the numbers 10, 20, 30, 40, 50, and 60 at equally spaced intervals.
4. Type in the numbers 250, 245, 240, etc., ending with 205, under the white bar.
5. Next, use the Text tool to add the number 10 in the black box, directly above the number 10 added in step 3. Select the number, then double click on the foreground color swatch in the toolbar. Next, choose the RGB color mode and enter a value of 10, 10, 10 in the RGB fields. Click OK. Repeat this process, ending with a value of 60, 60, 60 at the right end of the black bar.
6. Finally, using the technique outlined in step 5, enter the number 250 in the white bar, applying RGB color values of 250, 250, 250. Repeat this process, ending with a value of 205 at the right end of the white bar.

Note the point at which the numbers blend with the black and white strips. The screen image will tend to show more detail in the shadow areas than your finished print but will give you an indication of when highlights and shadows will disappear.

When printed, there will be a point at which the numbers are no longer decipherable. This is the limit at which your inkjet (or lab printer) can define detail in an image. When numbers can no longer be seen in the black strip,

Entering the color values in the Color Picker (steps 5 and 6).

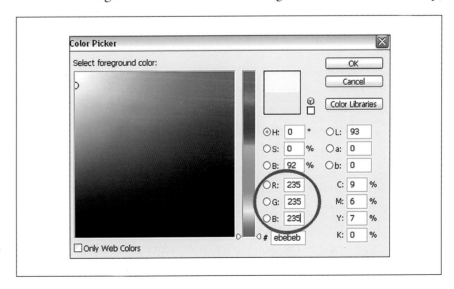

detail just blocks up. Likewise, when the numbers cannot be seen in the white strip, detail is blown out. Although detail may be visible on screen, it may not always be possible to print it (beware the white wedding dress).

Another problem with inkjets is the falloff of ink between areas of high contrast toward the highlight end. This is characterized by an area of the print where no ink has been laid on the paper, forming a ridge at the boundary of the two areas when held to the light.

Examine your test print and, depending on your printer, you will see that the numbers will start to disappear at around value 245. We can make sure that ink is placed on all areas of the image and get rid of the ridge by clipping the overall tonal range. To do this, open the Levels palette and clip the highlight end to 245. The resulting image will be indistinguishable to the naked eye from the original, and you will banish the problem of lack of ink in the high end of the print.

Below—Clipping the overall tonal range of your print. ***Facing page****—This image, called* The Cellist, *is a studio portrait made using only two lights. Postproduction work included vignetting, the application of the Nik Color Efex Pro Midnight filter, and enhanced saturation.*

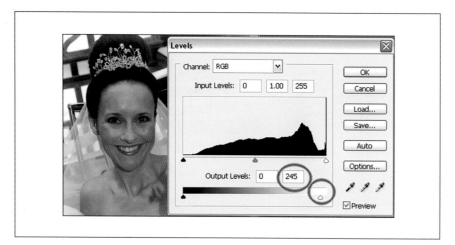

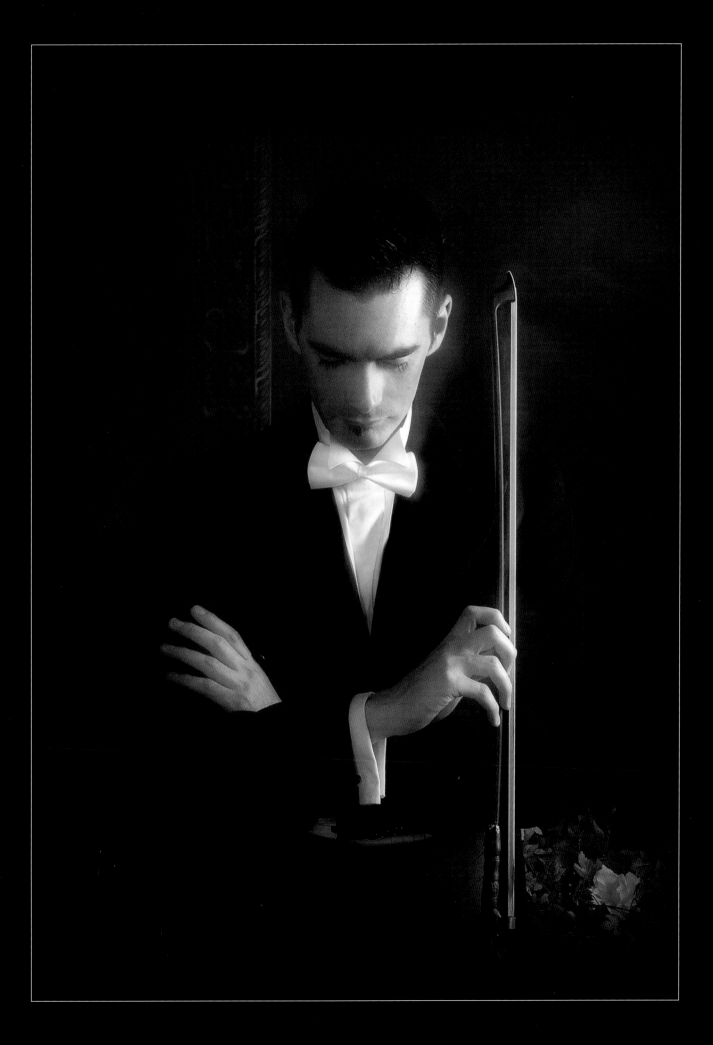

CONCLUSION

In committing my thoughts to print, I have attempted to keep it simple, imparting as much technical know-how as I can without completely confusing the reader. However, it's important to keep things in perspective. The workflows and techniques included here are simply one man's opinion, and I cannot say for certain that they are any better than the next author's methods—but one thing is for sure: they work.

Location portrait made at Red Rock Canyon, Nevada. The beautiful light is comprised of low sunlight and a little fill flash.

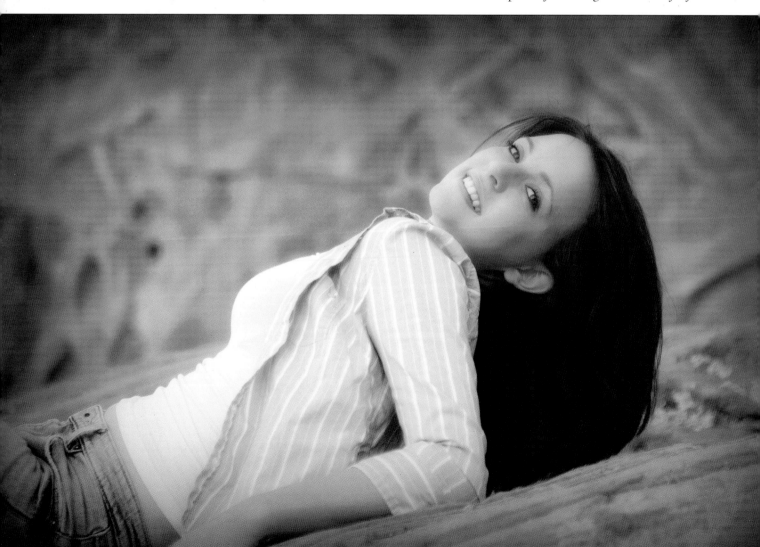

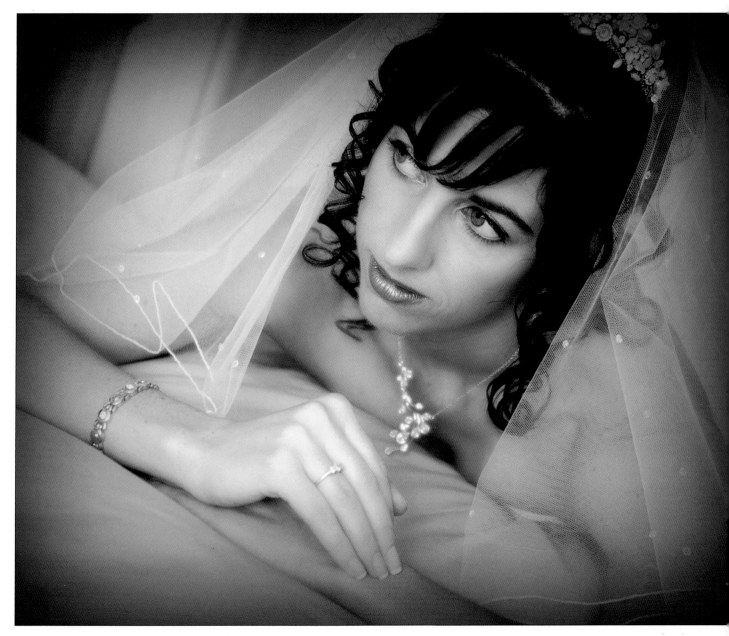

This stunning bridal portrait was made using window light only.

I have used the techniques and pursued the workflows included in this publication over many years, but I wouldn't dream of trying to tell someone that my way is best if they already have a good and practical style. There is an old saying, "If it ain't broke, don't fix it." But we *can* improve on it.

The only way that we improve is to continue to listen (myself included). If I thought I knew it all, there would be no point in attending lectures, networking with other great photographers, or reading their books! The content of this book is the summation of listening to and learning from other photographers of all statures, together with an unshakable self-confidence in the methodology. I have gained much from my time in photography and want to give something back that I truly believe will help photographers of all abilities. I hope that in reading this book you are able to improve in your own techniques, and I will have moved closer to that goal.

INDEX

THE DIGITAL DARKROOM GUIDE WITH ADOBE® PHOTOSHOP®

Maurice Hamilton

Bring the skills and control of the photographic darkroom to your desktop with this complete manual. $29.95 list, 8½x11, 128p, 140 color images, index, order no. 1775.

COLOR CORRECTION AND ENHANCEMENT WITH ADOBE® PHOTOSHOP®

Michelle Perkins

Master precision color correction and artistic color enhancement techniques for scanned and digital photos. $29.95 list, 8½x11, 128p, 300 color images, index, order no. 1776.

POSING FOR PORTRAIT PHOTOGRAPHY

A HEAD-TO-TOE GUIDE

Jeff Smith

Author Jeff Smith teaches surefire techniques for fine-tuning every aspect of the pose for the most flattering results. $34.95 list, 8½x11, 128p, 150 color photos, index, order no. 1786.

PROFESSIONAL MODEL PORTFOLIOS

A STEP-BY-STEP GUIDE FOR PHOTOGRAPHERS

Billy Pegram

Learn how to create dazzling portfolios that will get your clients noticed—and hired! $29.95 list, 8½x11, 128p, 100 color images, index, order no. 1789.

THE PORTRAIT PHOTOGRAPHER'S GUIDE TO POSING

Bill Hurter

Posing can make or break an image. Now you can get the posing tips and techniques that have propelled the finest portrait photographers in the industry to the top. $34.95 list, 8½x11, 128p, 200 color photos, index, order no. 1779.

MASTER LIGHTING GUIDE

FOR PORTRAIT PHOTOGRAPHERS

Christopher Grey

Efficiently light executive and model portraits, high and low key images, and more. Master traditional lighting styles and use creative modifications that will maximize your results. $29.95 list, 8½x11, 128p, 300 color photos, index, order no. 1778.

LIGHTING TECHNIQUES FOR FASHION AND GLAMOUR PHOTOGRAPHY

Stephen A. Dantzig, PsyD.

In fashion and glamour photography, light is the key to producing images with impact. With these techniques, you'll be primed for success! $29.95 list, 8½x11, 128p, over 200 color images, index, order no. 1795.

WEDDING AND PORTRAIT PHOTOGRAPHERS' LEGAL HANDBOOK

N. Phillips and C. Nudo, Esq.

Don't leave yourself exposed! Sample forms and practical discussions help you protect yourself and your business. $29.95 list, 8½x11, 128p, 25 sample forms, index, order no. 1796.

THE BEST OF PHOTOGRAPHIC LIGHTING

Bill Hurter

Top professionals reveal the secrets behind their successful strategies for studio, location, and outdoor lighting. Packed with tips for portraits, still lifes, and more. $34.95 list, 8½x11, 128p, 150 color photos, index, order no. 1808.

MARKETING & SELLING TECHNIQUES

FOR DIGITAL PORTRAIT PHOTOGRAPHY

Kathleen Hawkins

Great portraits aren't enough to ensure the success of your business! Learn how to attract clients and boost your sales. $34.95 list, 8½x11, 128p, 150 color photos, index, order no. 1804.

DIGITAL PHOTOGRAPHY BOOT CAMP

Kevin Kubota

Kevin Kubota's popular workshop is now a book! A down-and-dirty, step-by-step course in building a professional photography workflow and creating digital images that sell! $34.95 list, 8½x11, 128p, 250 color images, index, order no. 1809.

PROFESSIONAL POSING TECHNIQUES FOR WEDDING AND PORTRAIT PHOTOGRAPHERS

Norman Phillips

Master the techniques you need to pose all of your subjects successfully—whether you are working with men, women, children, or groups. $34.95 list, 8½x11, 128p, 260 color photos, index, order no. 1810.

THE BEST OF FAMILY PORTRAIT PHOTOGRAPHY

Bill Hurter

Acclaimed photographers reveal the secrets behind their most successful family portraits. Packed with award-winning images and helpful techniques. $34.95 list, 8½x11, 128p, 150 color photos, index, order no. 1812.

BLACK & WHITE PHOTOGRAPHY
TECHNIQUES WITH ADOBE® PHOTOSHOP®

Maurice Hamilton

Become a master of the black & white digital darkroom! Covers all the skills required to perfect your black & white images and produce dazzling fine-art prints. $34.95 list, 8½x11, 128p, 150 color/b&w images, index, order no. 1813.

PROFESSIONAL MARKETING & SELLING TECHNIQUES
FOR DIGITAL WEDDING PHOTOGRAPHERS, SECOND EDITION

Jeff Hawkins and Kathleen Hawkins

Taking great photos isn't enough to ensure success! In this book, Jeff and Kathleen Hawkins will show you how to become a master marketer and salesperson to maximize profits. $34.95 list, 8½x11, 128p, 150 color photos, index, order no. 1815.

MASTER COMPOSITION
GUIDE FOR DIGITAL PHOTOGRAPHERS
Ernst Wildi

Composition can truly make or break an image. Master photographer Ernst Wildi shows you how to analyze your scene or subject and produce the best-possible image. $34.95 list, 8½x11, 128p, 150 color photos, index, order no. 1817.

THE BEST OF ADOBE® PHOTOSHOP®

Bill Hurter

Rangefinder editor Bill Hurter calls on the industry's top photographers to share their strategies for using Photoshop to intensify and sculpt their images. No matter your specialty, you'll find inspiration here. $34.95 list, 8½x11, 128p, 170 color photos, 10 screen shots, index, order no. 1818.

HOW TO CREATE A HIGH PROFIT PHOTOGRAPHY BUSINESS
IN ANY MARKET

James Williams

Learn to identify your ideal client type, create the images they want, and watch your financial and artistic dreams spring to life—no matter the size or location of your studio! $34.95 list, 8½x11, 128p, 200 color photos, index, order no. 1819.

MASTER LIGHTING TECHNIQUES
FOR OUTDOOR AND LOCATION DIGITAL PORTRAIT PHOTOGRAPHY

Stephen A. Dantzig

Use natural light alone or with flash fill, barebulb, and strobes to shoot perfect portraits all day long. $34.95 list, 8½x11, 128p, 175 color photos, diagrams, index, order no. 1821.

BEGINNER'S GUIDE TO ADOBE® PHOTOSHOP®, 3rd Ed.

Michelle Perkins

Enhance your photos, create original artwork, or add unique effects to any image. Topics are presented in short, easy-to-digest sections that will boost confidence and ensure outstanding images. $34.95 list, 8½x11, 128p, 80 color images, 120 screen shots, order no. 1823.

THE BEST OF PROFESSIONAL DIGITAL PHOTOGRAPHY

Bill Hurter

Take a behind-the-scenes look at the methods that world-renowned photographers rely on to create their standout images. $34.95 list, 8½x11, 128p, 180 color photos, 20 screen shots, index, order no. 1824.

ADOBE® PHOTOSHOP®
FOR UNDERWATER PHOTOGRAPHERS

Jack and Sue Drafahl

In this book, Jack and Sue Drafahl show you advanced techniques for solving a wide range of image problems that are unique to underwater photography. $39.95 list, 6x9, 224p, 100 color photos, 120 screen shots, index, order no. 1825.